The Hypnotic Power of Crop Circles

The Hypnotic Power
of Crop Circles

Bert Janssen

Frontier Publishing

Adventures Unlimited Press

Cover design: ArtstudioHensens
Layout: Dsine

Frontier Publishing
PO Box 48
1600 AA Enkhuizen
the Netherlands
e-mail: fp@fsf.nl
http://www.frontierpublishing.nl

Table of Contents

"[The universe] cannot be read until we have learnt the language and become familiar with the characters in which it is written. It is written in mathematical language, and the letters are triangles, circles and other geometrical figures, without which means it is humanly impossible to comprehend a single word."

Galileo Galilei

Introduction

In the early-1990s, I came across a crop circle for the first time, in Holland. It fascinated me because there was no simple answer to why it should be there. Since then, I have visited dozens of crop circles and have been most impressed by those I have flown over. Seen from the air, the patterns have affected me deeply.

It was only later that I realised that 'seeing them from the air' was not the crucial factor. It doesn't matter if you are flying over them or if you look at photos taken from the air or if you study black and white diagrams of the formations. The result is always the same. It was the shapes, the lines and their harmony that were responsible for my fascination. There is always some kind of hypnotic effect in the shapes.

From the moment I realised this, I began to study these patterns. I wanted to know what made them so special. I wanted to know why they intrigue people, why they have this hypnotic effect.

In 1995 I began to reconstruct the symbols hoping to uncover their secret. Starting from scratch, I reconstructed many formations on paper and found the same basic pattern hidden in many crop formations. It turned out that none of the different elements within a crop formation are random. They are all related to each other. They have, because of the geometry of the overall symbol, very special ratios to each other. I came across many surprising peculiarities in respect to 'construction points' and 'construction lines', not the least of these being alignments in the landscape. Over a period of years I investigated more and more crop circles, I dug deeper into the subject, and bit by bit the pieces of the jigsaw came together. And what a jigsaw it is!

I asked myself many questions, such as what or who is creating the crop circles? Is there any real reason why they appear? If so, what is this reason?

What is the connection with us human beings? In the end I found answers to nearly all of these questions.

I did not study all the formations that have ever appeared. Far from it. So I do hope this book is an inspiration for others to do their own research into the geometric foundation of crop circles.

Bert Janssen
The Netherlands, 2004

Preface

This book which has crop circles as subject will only deal with the shapes of these mysterious symbols. There are many books written about the research done into other aspects of the crop circles:
- books with scientific research on plant anomalies;
- books with lots of facts that can be used as a kind of encyclopaedia;
- books with descriptions of strange substances or dead animals such as dead flies found in crop circles;
- in short, books that prove why the crop circles are a real phenomenon. The idea that these patterns in the fields were man-made, the work of pranksters, has long since been refuted. Crop circles are not a joke. Yes I admit, a few are man-made, but the majority are not. If you still have doubts about that, I suggest that first of all, you read one of the other books on the subject.

Although this book will not present any traditional proof that crop circles are not a hoax, which others have done many times before me, it will present material showing that there is far more going on in these formations than their outer shapes suggest. Not only can you read why a crop circle is a mysterious phenomenon, I will also show why it is not a purely natural one, like crystals, for example. There is literally much more going on with a crop circle then meets the eye.
You can never use the shape and the geometry of a crop circle as a measure to determine whether or not that particular formation was man-made. But, once you have established that it is not, its geometry suddenly becomes of the utmost importance, because this geometry tells a lot about the amount of 'thinking' that went into the design of the formation. And if it is not the work of human beings, it tells us a lot about whoever or whatever is doing this 'thinking'?
I will not discuss how the crop circles are formed, but I will shed some light on the questions: "Why do we receive them? What is their purpose?" In order to understand what this book is about, try to visualise a farmer

who is putting a fence of barbed wire round a field. In order to erect this fence he has to put many wooden poles in the ground. For that he normally uses a sledgehammer. Now imagine that a fly is sitting on one of these poles, while the farmer is just about to hammer down this pole. The fly sits just under the top and gets a huge shock when the farmer hits the pole for the first time. The fly is just recovering from this shock when the farmer hits the pole again. Again the fly feels the enormous blow and hears a loud boom.

After three or four hits the fly gets curious. He wants to know what is causing these blows and booms. After intensive research he finds the answer. The booms and blows are caused by a sledgehammer. From the viewpoint of the fly, this conclusion makes sense. However, we outsiders know better. We know that while it is a sledgehammer that is hitting the pole, the real cause of the booms and blows is the farmer who is swinging the hammer. The farmer delivers the blows and booms by means of a sledgehammer. The sledgehammer is just an instrument, a tool and not the primary cause. It is the same with the crop circles.

After years of intensive research the shape and size of the hammer are becoming more and more clear. Many books have been written about it. Most people agree by now that it is a sledgehammer of some sort that is putting the patterns in the fields, although there is still a lot of discussion going on about its size and shape. It is square or is it round? Has it a long handle or a short handle? What material is the sledgehammer made of? Is it made of wood, is it made of metal or perhaps plastic? The research done on this sledgehammer has been very intensive.

But the sledgehammer is operated by a farmer and up until now only very little research has been done on this farmer. Who is he? Why is he swinging a hammer? Is he trying to tell us something and if so, what is it? These are the questions that this book is trying to answer. It is a book about the farmer - whoever or whatever he is - who is swinging the sledgehammer. There are several approaches to this mystery: traditional science, intuition, channelling, the possibilities and options are many. I have chosen the same method that the farmer uses. He hammers shapes in the field and I have used these same shapes. Everything we want to know about the farmer is written in the shapes. It is just a matter of reading them - consciously and/ or subconsciously.

I shall try to unravel the mysteries surrounding this farmer by using the shapes of the crop circles. You will find dozens of diagrams in this book,

numbers, ratios, but it is not a mathematics book. It is even not a book on geometry. Even if you are put off by all the diagrams, drawings, numbers, triangles, I do urge you to read on. Try to see through the diagrams, behind the diagrams and all the number crunching. Try to see the message within the shapes.

And although this is not a book on geometry, it is like Galileo Galilei said. In order to understand both the language and the message, you need to understand the characters in which it is written and those characters are circles, triangles and many other geometrical figures.

I advise you to get a ruler, a set of compasses and some paper and make the drawings yourself. This way you will discover the incredible power of the crop circle symbols for yourself and in the end you will understand why we receive them, what their purpose is.

"When you have eliminated the impossible, whatever remains, however improbable, must be the truth."
– Sherlock Holmes

1. External Geometry

The late afternoon was warm when I arrived at the wheat field close to Winterbourne Bassett, just north of Avebury in the county of Wiltshire, England, on 30th July 1995. In this particular field was a crop circle that would have a great impact on me. I walked through the formation and was amazed by the way the crop was laid down. All the plants were laid down so precisely, so cleanly as if smoothed into place by flowing water. The border between the smoothly flattened crop and the standing crop was razor sharp. I had no idea that a crop circle could look so sophisticated.

But it was not only the way the crop was laid down that struck me. I was especially intrigued by the formation's shape, although in the beginning, the pattern was not clear and I had to study it for some time before I managed to work out what it was. I was surprised by how difficult it was to figure out the shape of a crop circle while walking through it.

Once the pattern became clear to me, I was startled. The many straight lines formed an equilateral triangle with squares attached to each side of the triangle. That brought Pythagoras' theorem to my mind: A squared plus B squared equals C squared. In fact, that ancient geometry theorem can be proved by placing squares on each side of a right triangle.

I was getting excited, I had a strange feeling in my stomach, a feeling that would come back every now and then in the years ahead, always at very decisive moments. I started walking faster through the crop circle. I felt a nervous tension. Was someone copying Pythagoras into the crop? Or was Something Else trying to make us pay attention to the rules of geometry? I had come to England to see the crop circles for myself, but had not expected to be confronted with questions like these. Now I had to know. What was going on?

The Winterbourne Bassett crop formation made me wonder about hidden mathematics in other crop patterns. It was at that moment that my passion for studying crop circle geometry was born. A great journey was laying ahead of me.

But where was I to start? I decided that the first logical step was to see if somebody else had already written about the geometry in crop circles. Very quickly I came into contact with Michael Glickman. Glickman is an

architect by profession, but has dedicated his life fully to the crop circles. He was the first person to show me the extraordinary geometrical features that some of these formations contained. Glickman also told me to study the work of John Martineau, especially the book that Martineau had written in the mid-1990s entitled A Book of Coincidence. One thing led to another. I read the book and I read articles written by another groundbreaking pioneer in crop geometrics: Wolfgang Schindler.

Schindler, together with Martineau, was one of the first to study the geometrics of the crop patterns. The methods used by John Martineau and Wolfgang Schindler can best be described as external geometry. First they would make black-and-white drawings of the crop circles as they were found in the fields. Subsequently they would add lines, especially tangent lines. To their own amazement they noticed that the lines they had drawn sometimes formed very regular geometric patterns. From then on they turned this process around. They started with geometrical shapes such as pentagrams and would look to see if the crop circle pattern would fit into these shapes. They did not take the existing crop circle shapes apart, but added elements to it. In a way they added geometry to the outside of the crop circle formations. Hence external geometry. The outcome of their efforts was astonishing.

I was fascinated by all their material and I realised that the crop circles John and Wolfgang studied, were all from the late 1980s and early 1990s. They were all crop circles that were claimed to have been made by people like Doug Bower and Dave Chorley. I remember them being asked if they had ever used geometry for their alleged efforts. Doug and Dave started laughing and their answer was definite: No, they had never used any form of geometry whatsoever in their designs. It was because of this denial that it became clear to me that Doug and Dave's claims that they had made the majority of the crop circles found during those days could not be true. Whoever or whatever made the crop circles, it was definitely not Doug and Dave. My fascination was growing and growing. The shapes of the crop circles themselves were stating very clearly that there was far more going on than just the simple claims of Doug and Dave. It didn't need any traditional scientific evidence to recognise this. John Martineau's and Wolfgang Schindler's work was showing this over and over again.

Let me give you an example of Wolfgang Schindler's work. The diagrams represent the crop circle that appeared on 7th July 1990, at Chilcomb Down near Winchester, England.

Chilcomb Down near Winchester, UK, 1990

If you draw a circle that has its central point in the left circle of the formation and meets the right circle of the formation, this newly constructed circle precisely touches two 'tramlines' that seemed to have nothing to do with the formation. (Tramlines are the tracks used by the farmer to drive his tractor through when he sprays the field.)

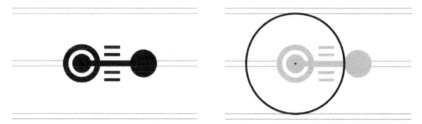

In the constructed imaginary circle we can construct a pentagram. Notice how the ring of the formation fits perfectly into the pentagram. You can draw another circle that has its central point in the right circle of the formation and meets the ring around the left circle of the formation.

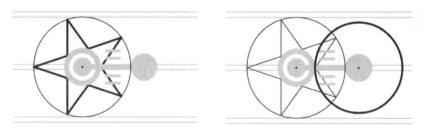

In this new imaginary circle, once again we can construct a pentagram. Now the right circle of the formation fits perfectly into the pentahedron of this pentagram.

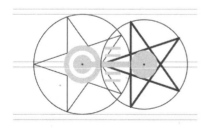
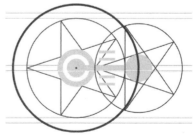

On top of that, we can construct a circle that has its central point in the left circle of the formation and its perimeter passing through the centre of the right circle of the formation. In this large, imaginary circle we can also construct a pentagram. And now it is the ring of the formation that fits perfectly into the pentahedron of this pentagram.

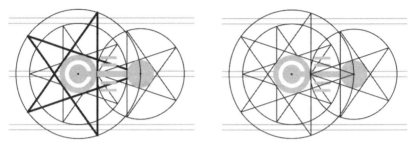

Anyone who knows anything about geometry and mathematics will know that all of this goes far beyond chance. There is no way that this could be a coincidence. This was just one simple example of the findings of Martineau and Schindler. They showed that the same principle was present in many other crop circles.

After I had read about this Chilcomb Down formation and the many others that Schindler and Martineau had studied I was astonished. Although later on, I started my own research, I never have forgotten the impact their work had on me. I would always try to apply Martineau's and Schindler's working methods, especially when I came across a so-called simple crop circle and many times I made mind-blowing discoveries that way.

Kekoskee, USA, 2003

For instance in 2003. On July 4th of that year, in the USA, Art Rantala, a retired truck driver, was up early making coffee in his workshop and watching a weather front that was moving across the Wisconsin area of Dodge County. His workshop was located a few miles from the town of Mayville and the village of Kekoskee, and situated at the top of a hill overlooking a wheat field across the street. While Art Rantala looked out the window, he saw to his amazement, during a period of 10 to 15 seconds, three circles appear in this particular wheat field.

"It looked like a lake. The waves, the wind blowing, and then all of the sudden this dark hole appears, like a black hole. And then immediately, one to the right then another to the centre of it," Rantala said.

Art Rantala is one of the lucky few that have seen a crop circle being formed. A truly amazing event. The pattern he had seen taking shape was a rather simple formation of three circles, two of which were connected with a path. One circle was flattened with part of the crop left standing in it. Another circle is in fact a ring with a circle offset in it At first glance, the shape of this formation is not something to get excited about.

I looked at this formation with Martineau and Schindler in the back of my mind. I drew some tangential lines and already, when only a very few lines were in place, I noticed that this formation had a very special feature. The position of the three circles was, in all its geometrical simplicity, very significant.

The three circles fitted precisely into an octagonal geometry. If the circles had been a little smaller or bigger, it would not have fitted at all. If the circles had been a little closer to each other, or a little further away, again, it would not have fitted. No, the three circles are of exactly the right size and in exactly the right place. I realised that over the years, I had seen so many of these simple but elaborate designs but I was still astonished again.

Another way to look at this geometry is to note that one element of the formation dictates the size and position of the next element. In Rantala's case this means that when for example. we start with the left circle, this circle determines the size and position of the middle circle and again these two determine the size and position of the right circle. All the elements are connected through geometry. They are all brothers and sisters. So simple, but so elegant and especially so intriguing. Isn't that astounding?

Wilhelminaoord, The Netherlands, 2003

In the same year 2003 I came across another so-called simple crop circle, this time in Wilhelminaoord, in the Netherlands. I was fascinated right from the moment I first saw this formation. Again this was a pattern that looked simple and straightforward at first glance. Just two rings and a little circle. See diagram.

By the time I started looking at this 2003 formation I had already analysed many, many of these "simple" designs in the previous years. I felt very strongly that there had to be more to this formation then just two rings and a circle. Probably because of my experience of having studied so many "simple" circles, my mind was trained to recognise hidden geometry. I felt confident and took out my tools to crack this one. It still took me quite some time to figure it out, but my efforts were rewarded. After I had finished it, I found I was looking at a formation that contained astonishing external geometry and which amazed me with its combination of simple design and complex geometry.

The formation was clearly based on nine-fold external geometry, something, which is rare. The geometrical fitting is pretty complicated, but very powerful. Here the working method is slightly different. Although I am not taking the formation apart, I do move a few elements of it. In order to fully grasp the power of this crop pattern, I will build up the forma-

18

tion step by step, rather than showing you the whole geometry in one go. I will start with the small central circle and build the formation around that.

The diagram on the left shows how nine-fold geometry is superimposed first of all on the small circle. Then a triangle is drawn through the intersection points of the small circle with the nine-fold geometry. The triangle is circumscribed with a circle.

The diagram on the right shows how a new circle is constructed with the aid of the nine-folded surface, which was constructed in the left diagram.

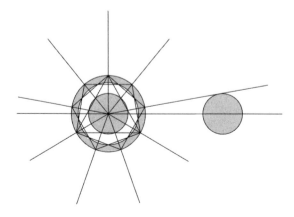

Have a good look at the previous diagrams. Notice how the size of the ring is determined by the nine-fold geometry, the construction of which was based on the central circle around the triangle. The next step was to copy the little central circle and to place it in such a way that its centre lies on the horizontal line. The distance is determined by one of the nine rays. The ray is just touching the small, copied circle on the right. Here again it is the nine-fold geometry that dictates the placement of this circle.

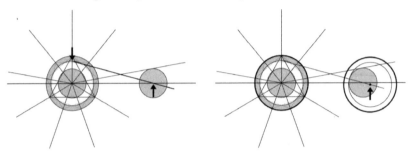

The diagram on the left shows how a line is constructed, starting inside of the ring at the exact spot as indicated by the arrow, and going through the centre of the little circle on the right (also indicated by an arrow). In the diagram on the right the ring is copied and placed in such a way that it is just touching the little circle and its centre is laying on the line that was constructed in the left diagram.

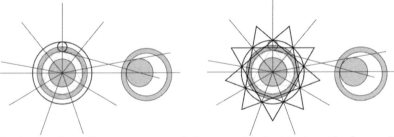

In the previous diagrams a new circle was added with the aid of a small circle (see diagram on the left) and this new circle was used to construct a nine-pointed star, which is shown in the diagram on the right.

The nine-pointed star was used to construct a nine-fold surface, and a circle circumscribing this nine-fold surface was constructed as shown in the diagrams above.

A triangle as shown in the left diagram is constructed and this triangle is used as a measure for another circle. The circle is just circumscribing the triangle. With this, the reconstruction of this "simple" crop circle is finished.

A rather simple crop formation and such a complicated and powerful underlying geometry. Every element of the crop circle is connected to all

the other elements. The size and placing of every element of the crop circle was determined by all the other elements.

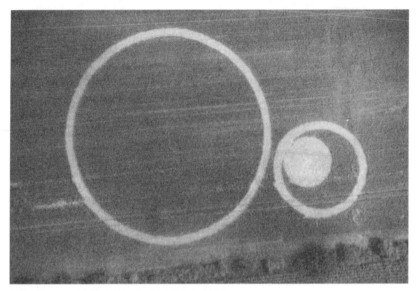

Wilhelminaoord, The Netherlands. July 22, 2003

Melick, The Netherlands, 1997

The crop circle that appeared on 18th July 1997 in Melick in the Netherlands shows this phenomenon even more clearly. Part of the formation was a little circle with three rings around it. At first sight the rings appear to be random, but let us have a closer look with the central circle as a starting point. We can circumscribe this circle with a virtual equilateral triangle. The tips of this triangle determine the size of the inner perimeter of the first ring. The outer perimeter of the first ring is determined by a virtual pentagram drawn around the central circle.

A virtual square circumscribing the first ring determines the size of the inner perimeter of the second ring. The virtual pentagon formed by a pentagram that circumscribes the inner perimeter of the first ring, determines the size of the outer perimeter of the second ring and at the same time, determines the size of the inner perimeter of the third ring.

The virtual hexagon formed by a hexagram that circumscribes the inner perimeter of the second ring, determines the size of the outer perimeter of the third ring. All the elements are connected to each other. The central circle determines very precisely the sizes of the three rings.

It was the discovery that one element of a crop circle determines the rest of the formation, that really added impetus to my research. I reasoned that if what I call external geometry is an intrinsic part of the crop circle phenomenon, then it is very likely that some kind of internal geometry would also form part of it. A geometry that would be hidden within the formations but would nevertheless be there. When I started to try and unravel this hidden geometry, I embarked on a magical journey through the miracles of crop circle shapes and geometry and I now invite you to travel with me.

2. Internal Geometry

Introduction

When I walked through that beautiful formation near Winterbourne Bassett on that nice warm late afternoon in 1995, I could not foresee that those moments would be so seminal for me for many years to come.

After studying the books and articles by John Martineau and Wolfgang Schindler, I got the urge to dig deeper into these powerful crop circle shapes. I had many questions and I wanted answers. Why did these patterns have such a hypnotic effect on me? And not only on me. Many others are affected by them. But what makes these crop circle shapes so powerful?

I had become fascinated by the work of Martineau and Schindler and others, but also, an unsatisfied feeling was growing inside me. Of the crop circles that had appeared from the mid-1990s onwards, by far the greatest number had a different shape from the ones studied by John and Wolfgang. There were still circles, dumbbells, dumbbells with rings appearing in the fields, but the majority had shapes that reminded me very much of mandalas. However, no external geometry could be added to these shapes. So I was not at ease. John's and Wolfgang's methods could no longer be applied. But I refused to believe that the magical geometry that was discovered by them was gone. It still had to be there, perhaps hidden inside the crop circle patterns.

So many people, perhaps even many more than ever, were fascinated by the crop formations. And most of them had only seen the formations in photographs taken from the air. These people had never actually been in the fields, they only had seen images but still became very much intrigued by the patterns. The power of the symbols was still there more than ever.

I had so many questions. How could it be that the patterns were so powerful? What is their secret? Why did people become affected so emotionally by the symbols merely by looking at them? Sometimes they even didn't know they are looking at a crop circle, but were still touched by it. Why? How?

I decided to approach the shapes from a completely different angle. One cold December

evening in 1995 I cleaned my desk. I threw everything off. Got myself a sheet of paper, a ruler and a set of compasses.

I urge you to do the same right now. Put this book aside for a moment, get a piece of paper, a ruler and a set of compasses. If you don't have a ruler and compasses, go to the shop and buy some. Reading about the mysteries of the crop circle shapes may give you some insight as to why crop circles are so powerful, but only by actually working with the shapes yourself, will you not only see why they are so powerful, but you will also experience this force.

Basic Pattern

The method I use is known as "construction technique". With this technique no measuring is done. I use the ruler to draw lines between (or passing through) two existing points, not to measure distances. I use the compasses for drawing circles or arcs from an existing central point to another point, thus determining the radius. Besides that, I also use the compasses for transferring the distance between two existing points. It can be transferred to a third point to create a new point at an equal distance, or it can be used to draw a circle or arc with the distance as the radius.

I start every new drawing with two arbitrary points. I use these points to draw a line or a circle (or both). Then every extension (next steps of the construction) uses points already given or created by previous construction steps. New points come into existence every time lines and circles intersect. It all sounds very complicated, but once you start doing it you will see that it is all pretty simple and straightforward.

After working for hours, days, weeks I stared at the paper in front of me. The result of all these hours of work was simple but truly fascinating. It turned out that the crop formations I had studied so far were all based on the same basic pattern. A pattern that formed the hidden core, the hidden heart of all these crop circles.

Let us have a look at this basic pattern. It is very simple and you have most likely made this pattern many, many times yourself. So please take your paper, ruler and set of compasses and construct the following.

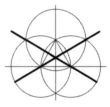

First draw a straight line and construct a circle with its centre on that line. Construct the same circle again but now with its centre on the spot where the first circle cuts the straight line. Construct the same circle once more, now with its centre on the point where the first two circles intersect.

 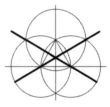

By connecting the indicated intersection points (see diagram), you get a triangle. An equilateral triangle. Now draw a line from one corner of the triangle to the opposite circle intersection point (see diagram). Repeat this for the other corners. You have now constructed the basic pattern.

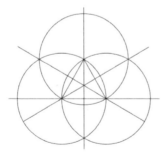

The three constructed lines in the basic pattern are perpendicular to the sides of the equilateral triangle and divide these sides exactly in half.

It is important to notice that this is not a coincidence, but the result of the geometrical construction techniques that have been used!

During the reconstruction of the different crop circles you will see that this happens over and over again. Nearly every time you think you have come across coincidence, you can be sure it is not. That is one of the wonders of geometry. And not only that. You will, for example, find perfect ratios. By this, I mean the relationship between different elements in a diagram. For instance, if you take a circle, circumscribe it with a triangle and circumscribe the triangle again with a circle, the area of the bigger circle will be exactly four times the area of the smaller one. Sometimes the relationship found will be identical to the relationship between different notes in music. These are called diatonic ratios and once again, these are not coincidental. It is all the consequence of the techniques that have been used. In geometry there is no such thing as coincidence. Everything follows strict rules. Only sometimes, but this is rare, you will come across coincidences. I noticed it a few times in crop circles and will mention it when the moment is opportune.

Winterbourne Bassett, UK, 1995

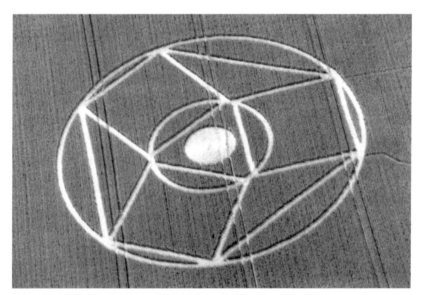

Winterbourne Bassett, Wiltshire, UK. 23 July 1995

Let us go back to that all important 1995 formation near Winterbourne Bassett.

This formation is such a good example, showing how all the different elements in a formation are connected to each other. Every element follows logically out of the previous one. There is nothing random about it and there are no coincidences.

All the steps of the reconstruction are shown. Try to replicate the diagrams with the aid of your ruler and compasses. This will give you a good idea of how crop circle reconstruction works.

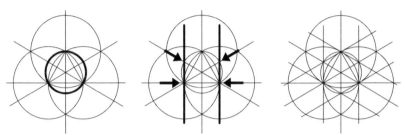

First construct the basic pattern. Then construct a circle with its centre in the middle of the pattern and its circumference just enclosing the equilateral triangle. Now draw lines as shown in the diagram. Draw another two sets of lines. Now you will have the diagram on the right.

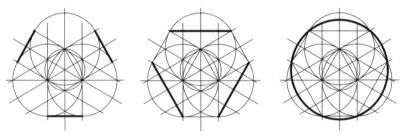

After a third set of lines, connect the intersection points as indicated in the diagram on the right. Draw another set of three lines connecting the same intersection points. See diagrams. Now construct a circle with its centre in the middle of the pattern and its circumference going through the same intersection points.

Construct another circle. This circle has its centre on the intersection point indicated by the bottom arrow. The circle itself goes through the intersection point indicated by the top arrow. See left diagram. Construct this new small circle again but now with its centre in the middle of the pattern.

With this, the reconstruction is finished. Just rub out the extraneous lines, fill in the centre circle and you have the crop formation as it appeared near Winterbourne Bassett. This is the crop circle that reminded me so much of Pythagoras' theorem: A squared plus B squared equals C squared. The following diagram can be used to proof this theorem of Pythagoras by proving that the surface of square 1 (which is A squared) plus the surface of square 2 (which is B squared) equals the surface of square 3 (which is C squared).

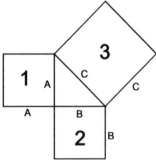

The similarity between this proof of Pythagoras's theorem and the Winterbourne Bassett crop circle of 1995 is obvious.

After I had finished the Winterbourne Bassett reconstruction I stared at the paper for a long time. I was puzzled. I had fiddled around with the ruler and compasses and got the basic pattern as a result. From there I reconstructed the Winterbourne Bassett crop circle of 1995 using the basic pattern as a starting point. Had I really figured all this

out in my imagination? Or was the basic pattern planted in my head just by my looking at the Winterbourne Bassett shape? Or perhaps it was co-creation. Perhaps parts of it were planted in my head and other parts were my own original thoughts. Perhaps I had been lucky that one of the very first crop circles I had visited was Winterbourne Bassett 1995. If this formation had been shaped differently, I would probably never have become interested in the shapes of crop circles. I would never have begun to study their geometry. Years later I realised that there was no coincidence involved.

I spent he whole winter of 1995 looking at crop circles and trying to reconstruct them. The outcome was really amazing. It turned out that many, many crop circles could be reconstructed using the basic pattern. Some of them were pretty simple, others were very complicated.

I want to show you some examples. These are from later years, but they demonstrate perfectly what I discovered. Besides that, it shows how the basic geometry of crop circles did not disappear over the years. New elements may have been added, but the "old" did not vanish.

Liddington Castle, UK, 2001

Folly Barn near Liddington Castle, Wiltshire, UK. 24 June 2001

In 2001 on July 24th, a very powerful symbol appeared in a field at Liddington Castle, Wiltshire, England. The geometry of this formation was so elegant that I must share it with you. And again I ask you to replicate the diagrams.

Start with the basic pattern and draw a circle fitting into the central triangle. Take the intersection point between this little circle and one of the diagonals as the centre of the next circle. This new circle just touches the bigger circle. See the arrow in the diagram.

Draw this circle three times and then draw a big circle that encompasses the whole drawing. You have now basically finished. Pick the appropriate lines and fill in the necessary surfaces.

Adam's Grave, Wiltshire UK. 4 August 2003.

Avebury Trusloe, Wiltshire, UK. 22 July 2001.

Avebury Trusloe, Wiltshire, UK. 13 July 2003.

Avebury, Wiltshire, UK. 28 July 2002.

Avebury, Wiltshire, UK. 6 July 2003.

Barbury Castle, Wiltshire, UK. 23 July 1999.

Beckhampton, Wiltshire, UK. 28 July 1999.

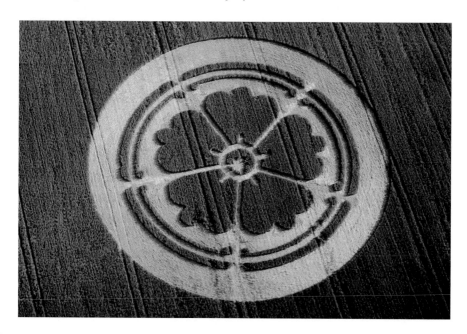

Beckhampton, Wiltshire, UK. 24 July 2001.

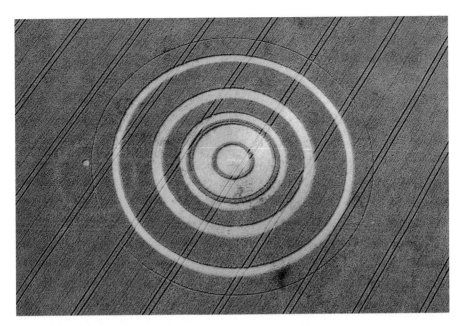

Beckhampton, Wiltshire, UK. 19 July 2003.

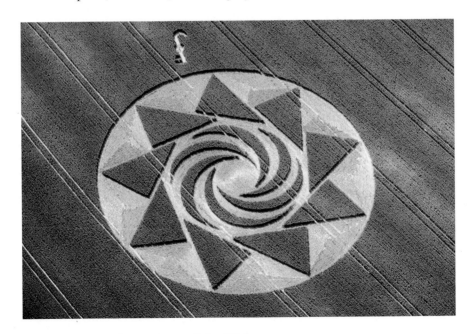

Cherhill, Wiltshire, UK. 17 July 1999.

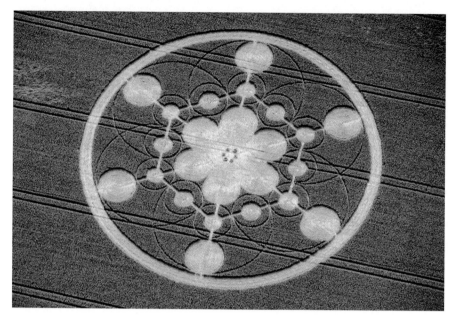

Scrope's Wood near Froxfield, Wiltshire, UK. 22 July 2003.

Giant's Grave, Wiltshire, UK. 3 August 2000.

Hackpen Hill, Wiltshire, UK. 4 July 1999.

Hackpen Hill, Wiltshire, UK. 20 July 2003.

Huish, Wiltshire, UK. 20 July 2003.

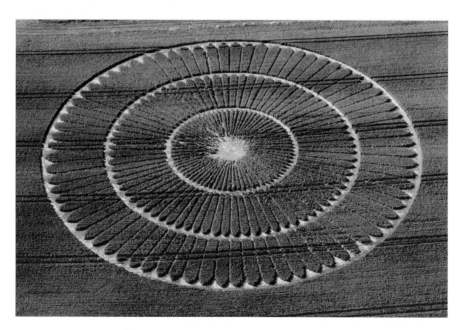

Knoll Down, Wiltshire, UK. 28 July 2002.

The diagram on the right shows how the basic pattern forms the heart of this formation. Although its geometry is simple, the pattern is very powerful. Of course, it may be the other way round. As with music, the best is often the simplest. The most powerful symbols are based on very simple, but elaborate geometry.

Ashbury, UK, 1996

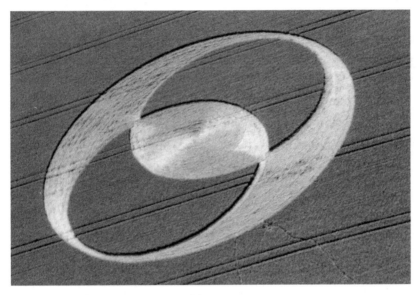

Ashbury, Oxfordshire, UK. 1 August 1996

Sometimes this simplicity goes so far that not even the complete basic pattern is part of it. The crop circle that appeared on 1ˢᵗ August 1996 near Ashbury, Oxfordshire, England is one of the best examples of this simplicity.

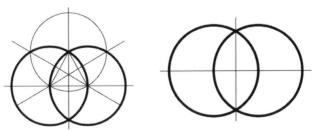

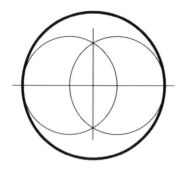

The diagrams speak for themselves. The formation consists of only three circles, but the symbol, which is called a vesica pisces, is very powerful and is often used in art and architecture.

Furze Hill and Clatford, UK, 1998

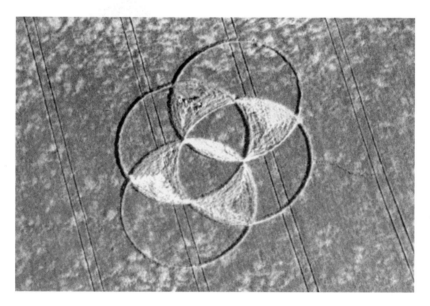

Clatford, Wiltshire, UK. 21 June 1998

I had just arrived in Wiltshire in 1998 and was rushing from Marlborough towards Alton Barnes to have a look at the beautiful crop circle that had appeared in the Eastfield, when I went by Furze Hill and noticed the crop circle on the slope of the hill. I stopped and walked up the hill on the opposite side of the road to have a better look

34

at this formation. I recognised it straight away. It was the basic pattern with only one additional circle, but what a difference that one circle made.

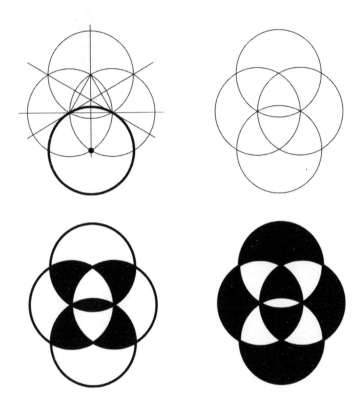

The diagram one the right shows the same geometry but inverted. This shape also appeared as a crop circle and came down at Clatford near Marlborough, about 24 hours before the formation of Furze Hill. Both formations were called "cats eyes" for obvious reasons. Just rotate them 90 degrees and you will see why.

Serpent Mound, USA, 2003

Up until now, the formations I have shown were all perfect in balance and full of harmony, and above all, they were very symmetrical. But to be in balance and full of harmony a formation does not have to be symmetrical. This is demonstrated perfectly by the crop circle that came down near Serpent Mound, Ohio, USA on 24th August 2003. This formation was far

Locus Grove near Serpent Mound, Ohio, USA. 24 August 2003.

from symmetrical, but the balance and harmony were perfect. And most importantly, the formation was based on the basic pattern.

We start with the basic shape of the "cats eyes" and turn it 90 degrees for convenience's sake.

Draw a new circle with the same radius as one of the four already existing circles and with its centre in the exact centre of the formation. Draw a little circle and a bigger one as shown in the diagrams.

Now we have enough circles. All that remains to do is to rub out the lines we do not need any more and fill in the appropriate surfaces. Notice how this shape is far from symmetrical but it is still very much in balance and very harmonious. (There were some additional little circles as part of the formation, but these did not affect the perfect balance and harmony and have therefore been left out.)

3. Size, Placing and Ratios

Introduction

Nowadays everybody knows about the Internet and most of us have a connection to it. In the mid nineties only computer nerds were aware of the world wide web. Hardly anyone had a connection to it. I did not and I had no such thing as email. If you wanted to know what was going on in Wiltshire, you had to go there and find out yourself. So, in 1996 I went back to England.

People have asked me many times, if I would go to Wiltshire even if there were no more crop circles. I never have to think about the answer. It is yes. Wiltshire is such a magical place. It can overwhelm you once you open yourself up to it. There is something in this area, that I have never experienced anywhere else before. It is difficult to describe, to put into words, but once you have been there, you will know exactly what I am talking about. One could easily say that part of the magic is due to the numerous crop circles that have been discovered in Wiltshire, but I think it is the other way around. The crop circles are attracted to that area because of the magic of the landscape.

Wiltshire has a kind of "fatal attraction" for the crop circles. The hills are bare, hardly any trees grow on them and they are known for the many white horses that have been carved into them. If the top layer of soil of the surface is removed, white chalk will appear. More than 4,000 thousand years ago, people did this at Uffington and the horse or dragon, or whatever figure it is, is still visible. In later years other figures, mainly horses, were carved in the slopes of the Wiltshire hills.

Stonehenge is situated in Wiltshire; so is the 5,000 year-old huge stone circle of Avebury; and also the neighbouring Neolithic Silbury Hill, Europe's highest manmade hill. Less than two miles down the road, you will find the long barrows of West and East Kennet as well as the Stone Avenue and the Sanctuary. All of them thousands of years old. There are

so many megalithic monuments in Wiltshire. Then there is the Mound in Marlborough in which many people say Merlin the great magician is buried.

If Wiltshire's magic is not caused by the crop circles, the question arises as to whether it is because of all the ancient sites, or was the magic always there and the ancient people, and later the crop circles, came to this area for the same reason as I do? We will never know, but the magic is definitely there.

I know so many people who are aware of this indescribable quality of the landscape. They all feel the same, they go through the same experience. They all have the idea that there is some kind of invisible dome over Wiltshire, like a cheese cover. Like me, they feel it when they enter the magic. There are very definite points of entry, and those points are the same for everybody. It is where the magic starts. This all became very clear once more when I arrived in Wiltshire in 1996.

I had literally just arrived, and was getting out of my car when I ran into Michael Glickman. He recognised me immediately and with his characteristic friendly voice said: "Hello. I see my friend from Holland has arrived. Welcome". This was unmistakably

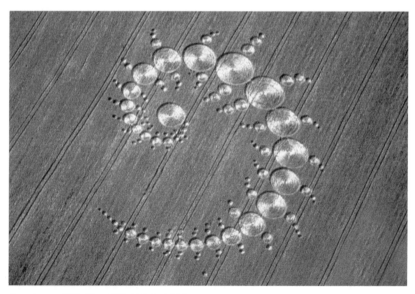

Stonehenge, Wiltshire, UK. 7 July 1996

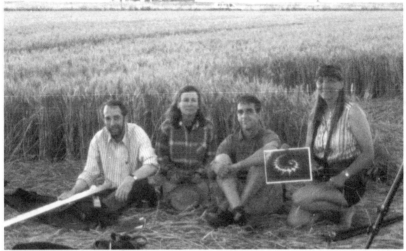

July 1996 in the Julia Set crop circle. From left to right: Michael Glickman, Patricia Murray, Bert Janssen and ilyes who is holding the photocopy of the aerial photo of the Julia Set.

Michael Glickman. He carried some strange looking equipment with him. "I am going to do some measurements in a crop circle" he replied in response to the questions on my face. "Would you like to come along?" Of course I wanted to come along. Even though I had just arrived after a long journey, this is what I had come for.

The crop circle in question turned out to be near Stonehenge. It was already late in the afternoon when we arrived. A very warm afternoon and it looked as if we would get a beautiful sunset. I started walking the formation while Michael was doing the things he had planned to do.

I was not immediately impressed by this crop circle, mainly because it was partly trampled by the hundreds of people who had already walked through it before me. But I had that strange and inexplicable feeling of excitement in my stomach again. Although I was not really impressed at first, I was still excited. While I tried to figure out the shape of the formation, I realised again how difficult it is to do so in the field. In the end I turned to Michael and asked him if he knew.

He stared at me with an expression as if I had asked him to take me to the moon. "You really don't know?" he asked with maximum disbelief in his voice. No, I actually didn't know. How could I? I had just arrived from Holland. Michael didn't wait for an answer from me, got a photocopy out of his bag and handed it over to me.

41

I looked at the paper and I was stunned, I was paralysed. The photocopy was a copy of an aerial photograph of the crop circle. The same thing that had happened to me at Winterbourne Bassett, happened again on July 17th in a crop circle just beside Stonehenge. I could not say a word. This was definitively not just a crop circle. I was looking at the crop circle that later on, would become world famous under the name "Julia Set". I looked up and saw the disbelief still on Michael's face. "I really didn't know, I swear I really didn't know", I said. Again I looked at the paper and my mind was wandering away. Because of my mathematical background I immediately recognised the pattern of the crop circle. It was a fractal, a Julia Set named after the French mathematician Gaston Julia. Again, mathematics in the crop, as in 1995 at Winterbourne Bassett, but this time it was a complete different form of mathematics. This time a fractal! I was really amazed and was taken aback by the shape. I could not get over it. I had just arrived in Wiltshire and I was already surrounded by magic.

Questions came in my mind, questions, which would repeat themselves many times during that summer. What does this fractal mean? Why suddenly a shape that is so easily recognisable and why a fractal? These questions and the shape of the crop circle, the Julia Set, kept my mind busy throughout that summer during my stay in Wiltshire.

Later that season, on July 29th, a huge crop circle appeared on the slopes of Windmill Hill. It contained three Julia Sets in one crop circle, and for obvious reasons it was called the triple armed Julia Set. Again a fractal. And a couple of days later a relatively

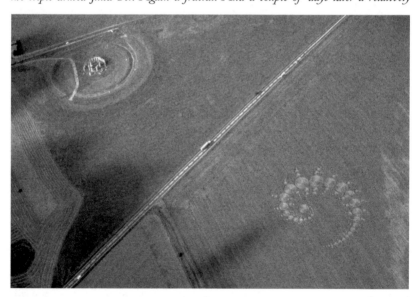

The Julia Set and Stonehenge, Wiltshire, UK. 7 July 1996.

small crop circle was found at Liddington Castle. Although not a real fractal, it still had all the characteristics of its bigger sister, the Julia Set, at Stonehenge. That summer I went like a tourist to all the usual places in Wiltshire - Avebury, Silbury Hill, the Long Barrow of West Kennet. I did night-watches on Knap Hill, Woodborough Hill, Golden Ball Hill. But all the time numbers were rushing through my head. I was captivated by the fractals. Even long after my return to Holland, my mind was still occupied by these mathematical shapes. I studied them, I wrote articles about them, I gave lectures about them, about the mathematics behind the fractals, about rational and irrational numbers. This went on all through the winter of 1996 – 1997.

Winterbourne Bassett, UK, 1997

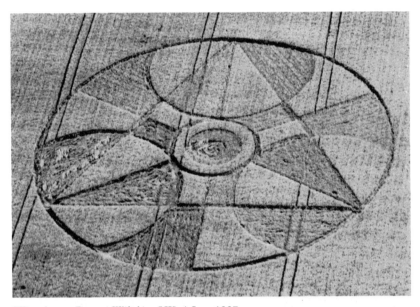

Winterbourne Bassett, Wiltshire, UK. 1 June 1997.

Sometime in early spring 1997 I finally became connected to the world wide web. From that moment on I could follow all the developments in Wiltshire on the Internet while sitting in my armchair in Holland.

On 1ˢᵗ June 1997 I received an email telling me that a new formation had been discovered near Winterbourne Bassett. I was immediately on the alert. A new crop circle near Winterbourne Bassett, the place where it all had started for me nearly two

43

years before. Quickly I opened the attachment to see the photo of this newly found crop circle. I looked at it and I was stunned. Again. I saw right away that 'my' basic pattern was hidden in this new formation, I could smell it, it shouted at me. After a whole year of fractals, numbers, more fractals, more numbers, my mind was instantly filled with shapes again. The nervous tension in my stomach was back as well, for me a sign that something very important was about to happen. Hastily I got my ruler and compasses and started trying to reconstruct this new crop circle. I drew circles, lines, triangles, more circles.

I stared at the paper quietly, giving my drawing time to sink in. There was an element in the finished drawing that I had not seen before. At least I had never noticed it. Perhaps it had been part of many crop circles from the past, but this was the very first time I was aware of it. And it silenced me because I recognised immediately the far-reaching consequences of this feature. It was not really a new element in the drawing that had surprised me. No, it was the absence of an element in the actual crop circle that really had stunned me. There was an element in my drawing without which I could not complete my reconstruction, but this element could not be found in the crop circle itself.

I suggest we reconstruct this formation again together and do all the necessary reconstruction steps together in order to see which element I am talking about. If you follow all my instructions, you will discover why I was stunned.

Start off with the basic pattern and within this pattern, construct an equilateral triangle as shown in the diagram. Now construct a circle with its centre in the middle of the pattern and its circumference going through the indicated intersection points. This circle is very important. Take another look at it and notice that the size and placing is not random. They are both predetermined by the previous steps. This circle plays an important role later on in the construction.

Let us carry on. Construct a circle with its centre in the middle of the pattern and its circumference just touching the bigger triangle. Now construct three circles of the same size as the previous one, but with their centres on the indicated intersection points.

The three circles just constructed have a fixed size and have a predetermined placing. The big triangle rules the size and the big circle rules the placing. From here it takes only a few steps more to finish the reconstruction of the 1997 Winterbourne Bassett formation.

Three more circles have to be added to finish the reconstruction. They all have their centre at the middle of the pattern. The first circle just touches the three previous constructed circles. The second one just encloses the big triangle and the third circle just fits into the small triangle.

The only thing left to do is to pick out the right objects or in other words: rubbing out the appropriate lines. The places where the crop was flattened we colour black. The places where the crop was still standing remain in white.

I am sure you will agree that the reconstruction was relatively simple. Perhaps this is also why I saw straight away that it would be possible to reconstruct it with the aid of the basic pattern. However, there is something very peculiar with this shape. Actually there are two things which are very strange.

First of all, I want you to notice that the circles on the points of the triangle fit exactly in the central triangle. This is very odd. There is no real reason for it. There is no law telling these circles what size they have to be, at least none that I am aware of. They could have been smaller or they could have been bigger, but that is not the case. They are exactly the "right" size. They fit exactly into the central triangle. I urge you to let this coincidence sink in for a while.

The other peculiarity is far more strange. Take a good look at the position of the three circles that I have just discussed. Look at the element that determines their position. Go back a few diagrams and notice how the central points of these three little circles are laying on a central circle. These central points could have been closer to the centre of the formation or they could have been further away, but once again, they are not. They are positioned exactly on this central circle. Without this circle it would have been impossible to place the three little circles on the correct spot. Without that central circle I would have had to guess the position of the three outer circles. But that would have meant that the formation could not have been reconstructed.

Reconstructions do not work with guessing. Each new reconstruction starts basically with two arbitrary points. These points are used to draw a line or a circle (or both). Then every extension (next steps of the reconstruction) uses points already given or created by previous construction steps. New points come into existence every time lines and circles intersect. There is no guesswork involved.

After I had finished my first reconstruction of the 1997 Winterbourne Bassett formation, I looked for a long while at this all-decisive central circle. First of all because I was amazed that these little circles followed the rules of construction so strictly, but then I

46

was really shocked to see that this all-important central circle could not be found back in the actual crop circle as it was found in the field. I studied the aerial picture for a long time. I even contacted the people who had been in this crop circle. I received confirmation after confirmation that this central circle was simply not there in the actual crop circle. I was really puzzled.

From a constructional viewpoint every element of this crop circle had the correct size and was placed at the correct spot. The whole crop circle, every single element within it, followed the strict rules of geometrical construction. However, one element was missing. All elements that were present were all of the correct size and at the correct spot, but one very important element was definitely not there. On one hand the crop circle followed the rules strictly, but on the other hand it skipped a step as well. A step without which I could not reconstruct the formation.

I looked from the drawing to the aerial picture, from the aerial picture to the drawing. Over and over again. Slowly it came to my mind that the absence of the central circle, while the rest was obeying the rules of geometrical construction so perfectly, could not be a coincidence. It looked to me as if the circle was left out on purpose. But why?

Bit by bit, the idea grew in me that there could be a message hidden in this crop circle pattern. It was the first time that I really considered this possibility. It simply could not be a coincidence, there had to be a reason for it. In later years this proved to be right.

Barbury Castle, UK, 1999

In 1999, two years after the appearance of the 'Harlequin', as the 1997 Winterbourne Bassett formation was nicknamed, I walked up to the top of Barbury Castle, a 5,000 year-old Iron Age fort also located in Wiltshire. This stronghold comprises a double line of earthworks, occupying a 4-hectare site, with entrances on its eastern and western edges. One of Barbury's attractions is the view - the main reason why Iron Age man chose to occupy the site 2,500 years ago. It was also the reason why I walked up.

At the foot of Barbury, a brand new crop circle had been laid down. Looking at it from the top down, I was deeply affected by the shape of this new formation. I got that feeling in my stomach again, the sign that the crop formation probably contained some special features.

I had of course studied many crop circles between the moment I discovered the very strange feature in the 1997 Winterbourne Bassett formation and my observation of the Barbury Castle crop circle of 1999. I had come across numerous other crop circles that shared the same feature as Winterbourne Bassett, but the 'Crescents' formation of 1999 at Barbury

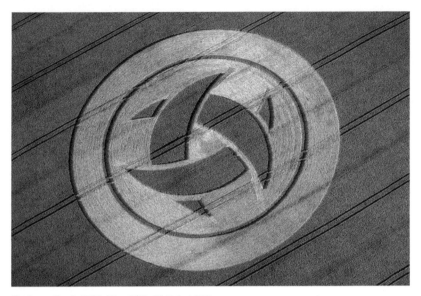

Barbury Castle, Wiltshire, UK. 23 July 1999

Castle, as it turned out, were really amazing. It showed the same features as the Winterbourne Bassett formation of 1997 but in a much stronger way. Two essential elements for the reconstruction could not be found in the field. The elements that were present in the field all fitted precisely in the reconstruction I made on paper. It is the size and placing of the three crescents that made this formation mind-boggling. Get your paper, ruler and compasses and let us go over this beauty together.

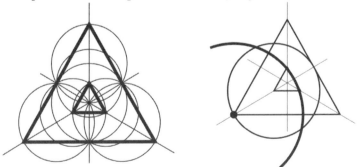

Starting with the basic pattern it is not difficult to get to the situation as shown in the left diagram. I am not going to show how that is done, consider it as an exercise and try to get there by yourself.

48

The next step is very important. Construct a circle with its centre in the left corner of the large triangle and with its perimeter just touching the side of the small triangle. Now do the reverse! Construct a circle with its centre in the left corner of the small triangle and with its perimeter just touching the large triangle. The two circles overlap and form a crescent.

This crescent is at exactly the same place and of the same size and shape as the crescent that could be found in the Barbury Castle formation of 1999. That is really amazing. If the crescents had been a little fatter or a little thinner, none of it would have fitted anymore. The same goes for the placing of the crescents. If they had been a little further apart or a little closer to each other, again the geometry would no longer have fitted. The geometry only made sense if the crescents were of a fixed size and at a fixed position and it turned out to be exactly the case in the field!

Notice, and I really want to emphasise this, that the two triangles were absolutely necessary for the construction, but they are missing in the final design. They disappeared, they were rubbed out. You can do that on paper, but not in crop! You cannot first of all make two triangles in crop, then use them to align and construct three crescents and finally erase them by straightening up the crop again. That is impossible, even for a natural phenomenon. So that is not the way it happened. Nevertheless, the crescents are there and they are of the correct size and in the correct position. The two triangles could not be found, they were simply not there and had never been there. It is a riddle. On one hand it is obvious that the crescents were constructed in the same way that I did on paper; on the other hand that absence of the triangles proves that this is impossible.

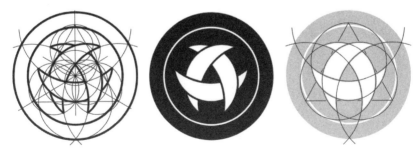

Perhaps you did not notice it, but you did this rubbing out before. Look at the Liddington Castle formation of 2001. The triangle stipulated the size of the little central circle. But this triangle, which was an absolute must for the construction, was not to be found back in the end design.

When you study more and more crop circles (see my website www.bertjanssen.nl/cropc/) you will find that this is true for a lot of formations. In many formations you will find that the different elements that make up the formation are not just random bits and pieces. They are all related to each other through their internal geometry. I want you to realise that this is really amazing. If you were to make a freehand drawing of something like the three crescents that appeared at Barbury Castle in 1999, you would be very lucky if you drew something that had elements that are all geometrically related to each other. The only way to achieve this is by making the drawing using construction techniques - by using ruler and compasses. A random drawing will not do.

Now look again at the crop circles. They all have this internal relationship as if they are all made using a ruler and a set of compasses. It is essential to realise that we are looking at a real phenomenon, not some joke - a phenomenon that seemingly obeys very strict rules of construction. Again, this is quite extraordinary.

But it goes further. When you use construction techniques to make a drawing, you go from step to step, from stage to stage. You can not skip a step. Every step is needed to make the next step possible. However, in crop circles we find that on one hand traditional construction techniques are used, but on the other hand steps that are required are sometimes skipped! It looks very much as if these steps were taken and the necessary stages were drawn, but later on they were removed. You can do that on paper, but not in a field. Truly amazing.

We can draw the following conclusions:

1. The size and placing of the different elements in a crop formation are not random but do follow strict geometrical construction rules;

2. Because of the internal geometry some elements will have special (diatonic) ratios to other elements;

3. Some of the necessary construction elements can not be found in the final design.

It was sometime in the early summer of 1997, the crop circle season was well underway and I was about to go to Wiltshire, England. I had just finished the reconstruction of the Harlequin and was looking at the diagram in front of me. There was a storm raging inside my head. My thoughts went so fast that I could not keep track of them. Bits and pieces of information would pop up and then disappear as quickly as they came. Bit by bit my mind came to rest and my thoughts were shaping themselves in such a way that I could interpret them. I had the strong feeling that it was not me who was shaping these thoughts. Somebody or something was trying to tell me something. Somebody or something was desperately trying to get my attention and was saying, or rather it was screaming: "Pay attention. We follow your techniques, but within that we do things you can't. Ha, ha!"

I knew already that most crop circles were not the work of pranksters, but for the first time I realised that it was also not a normal, though unknown natural phenomenon. Up until then I had come from thinking that all the crop circles were just one big hoax to the point where I realised that there was something far greater going on. That had been a huge step for me. To realise and to admit that not all crop circles could be explained away by jokers and pranksters, had been a major victory over my initial scepticism. Now I was looking at this diagram that was shouting in my face: "We are not a natural phenomenon. We are not like crystals or like other geometrical shapes you will find in nature! Why don't you look deeper and you will see it yourself". I had a hard time. This was difficult for me to accept, but the seed was sown and soon it would germinate and begin to blossom.

4. Construction Points

In 1997 I was looking for the formation that had been discovered earlier that week near Etchilhampton on 1ˢᵗ August. I knew exactly which field the crop circle was in and I was told the circle itself was not difficult to find. But when I arrived at the field I couldn't see it. Sometimes it is difficult to spot a crop circle from the side of the field, so I was used to a situation like this but I still was facing a problem. Which tramline to take? While I was standing there at the field contemplating this dilemma, I spotted a deer that came from an adjacent field and in front of my eyes, jumped through the field I was about to enter. Intuition told me that this was a sign that I should follow the same tramline that the deer had taken, and sure enough, she showed me the way straight into the crop circle. I was not even surprised that this should be so. It seemed that the deer had deliberately appeared in order to lead me to the right spot

Walking through the crop circle, again it took me some time to figure out its shape. Parts of the formation resembled rotor blades. In 1995 I had seen a formation with 5 blades near Kingsclere. This one near Etchilhampton had six. I could see the challenge trying to reconstruct these rotor blades.

Later on when I saw an aerial photo of this formation, there was no escape anymore. I had to give it a try. The pattern felt so much in balance, so full of harmony that I had to know if this could be reconstructed. I just had to. So I tried and it was no surprise to me that it was indeed possible. Everything fitted, all elements were again of exactly the right size and were situated at exactly the right spots. I was really satisfied and was looking at the result of my reconstruction with a smile on my face when suddenly I stopped smiling and began to frown. That well-known feeling in my stomach started again, that give-away nervous tension that I am on to something real important. For a long time I looked at the drawing to make sure I was not mistaken, but the longer I looked the more convinced I became that what I was looking at was of great importance.

Before I show you what it was I discovered that was so important, I want you to pick up your compasses. The set of compasses is a human invention. We humans invented a tool in order to make perfect circles and this tool we called a set of compasses. Nature doesn't need such a tool. Na-

ture can produce beautiful circles without the aid of compasses. We could also do without and make circles using cups or other round objects, but then the object used dictates the size of the circle. That is not what we want. We want to be able to make circles of every conceivable size and for that we need a set of compasses. There is no escape.

As you know by now, geometrical constructions can be made by using just a ruler and a set of compasses. The latter are obviously used for making the circles. In order to do this you must put the needle of the compasses in the paper. The places where you put the needle in the paper could be called 'construction points'.

While reconstructing the many different crop circles, I had noticed that these construction points were nearly always at special places. They were on spots where the crop was downed in the actual crop formation or in a tramline. At first this gave me rather a shock because it meant that you could replace the needle of the compasses by a person holding a rope. My first thought had been that I had been wasting my time. It was the work of human beings after all! The implications of the feature I found in the 1997 Etchilhampton formation were so far-reaching that I actually had to convince myself again. It took a while but then I realised that my own findings and all the scientific research done on crop circles signified that it was impossible that it was done by human hand.

Besides all of the plant anomalies that have been found, think geometry. Think of the different elements that are necessary to construct a formation but which can not be found in the final design. These are impossible for humans to carry out in a field. Nevertheless, I could not find a construction point that was placed in 'standing crop'.

In the diagrams are some examples of reconstructed crop formations shown. The construction points that have been used are marked as little circles.

In the previous diagrams you have seen how all the so-called construction points were at places where the crop was downed. Sometimes these points are laying well away from the crop circle but still not in standing crop. Take for example a look at the 1992 crop circle near Barbury Castle.

Barbury Castle, UK, 1992

Much has been written about this so-called "Mother of all Pictograms". But up until now nobody has looked at this specific construction feature that I call "construction points". With the Barbury Castle 1992 formation we see a new situation. There is a new element. One of the construction points used lies far away from the actual formation. But again it is NOT in standing crop. The construction point mentioned lies exactly on a spot where a tramline was running!

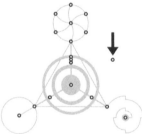

Although I have come across this very special feature more than once, it is not really common and until the Etchilhampton formation appeared, I had never really studied these construction points. I was still of the opinion that they were all quite likely to be natural. Nothing to worry about, you might say. Etchilhampton 1997 changed this opinion dramatically. Lets have another look at the 1997 Etchilhampton formation and see how this crop pattern elevated the construction points to a whole new

level. Just as the deer had shown me the way into the crop circle, the circle itself, in its turn, showed me a new direction in my journey through the magic of crop circle geometry.

Etchilhampton, UK, 1997

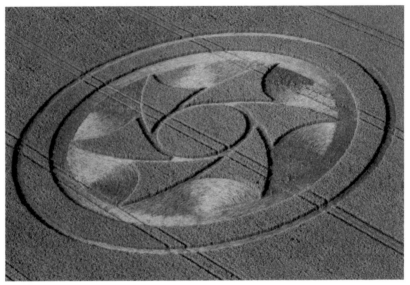

Etchilhampton, Wiltshire, UK. 1 August 1997

I will show you parts of the reconstruction of this formation. Again no construction points could be found in 'standing crop', although with this crop circle everything went a huge step further. The formation contained an element that was absolutely necessary in order to avoid the situation of having construction points in the standing crop! I will not show all the construction steps but just the crucial ones.

The diagrams show the steps taken to determine first of all, the size of a radical circle, which is then put into place.

The circle constructed in the diagrams above is used to determine the position of six new circles.

The next diagram shows the finished reconstruction with the construction points that are used, indicated as small circles.

The construction point in the centre of the formation was situated just on the edge of a tramline. Once again, not in standing crop.

It is the ring that I now want you to have a very good look at. Notice that six construction points were situated on this ring round the formation. If this ring had not been there, those six points would have been in the standing crop. Furthermore if the ring had been bigger or smaller, again the six points would have been in the standing crop! Remarkably enough, we see firstly, that the ring is there and secondly, that the ring has exactly the 'correct' size. The ring <u>had</u> to be there! This ring avoided the situation of six construction points in the standing crop. This ring was not a coincidence. This ring had a definite purpose.

It was because of this ring together with the fact that six construction points were located exactly on this ring, that I realised the vital importance of this crop circle. Later on I studied many more crop circles to see if this was a coincidence, but it turned out not to be the case. Nearly all the formations I studied had no construction points in the standing crop. I always had to put the needle of the compasses on spots were the crop was down or in the tramline.

Again I want to stress that nature does not need a set of compasses to make circles. She makes them naturally. For example it is very easy for nature to make rings in a field without having to have the central point, the point where the needle would go in the paper, in downed crop. Why should she?

With regard to construction points we can come to the following conclusions:

1. In the studied formations the construction points necessary could never been found in standing crop;

2. Some formations have elements that are strictly necessary to avoid construction points in the standing crop.

For a long time I stared at the paper with the diagram and noticed how this ring was staring back at me. The deer came back into my mind; how she had shown me the way to this crop circle and how this crop circle in its turn was showing me new paths.

The more I thought about it, the more convinced I became that the ring had been put there to show me something. I realised that when I was given the assignment to make this crop circle, I would have to come up with this ring feature, just to avoid having to walk through standing crop. Yes, I would have to think of such a feature.

While this thought went through my head I suddenly became conscious of the fact that this ring needed "thought" to come into existence. I would definitely "think" of such feature. But who or what had done the thinking with the 1997 Etchilhampton formation? Why this ring?

For days these questions went through my head. Why should a feature that we humans need to avoid a certain situation, occur? This situation only happens because we have to use a set of compasses to make the circles. It looked as if whoever or whatever had made this crop circle, had taken into consideration the fact that we human beings can only reconstruct this pattern with the aid of a set of compasses. Something or someone had

taken our shortcomings into consideration. I could not come to any other conclusion. This all went far beyond a natural phenomenon. Nature doesn't think this way. But who or what is doing this thinking? Whoever or whatever was teasing me, was saying, in a way: "Come on, think! Who are we that we do things the way we do and especially why do we do them?"

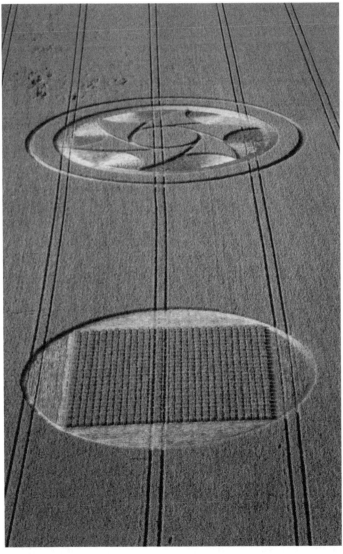

Etchilhampton, Wiltshire, UK. 1 August 1997.

5. Construction Lines

Introduction

If you take a closer look at the lay of the crop in a crop circle you will sometimes find pathways of crop under the general lay. These pathways are on average a foot wide and it often looks as if they represent the general layout of the formation. They look like 'construction lines' and for obvious reasons, they give the crop circle a very bad reputation. A lot of people think that these lines are the ultimate proof of human activity. But it is not that simple.

Kekoskee, USA, 2003

Let us go back to Kekoskee where, on 4th July 2003, Art Rantala saw a crop circle being formed. Notice the pathway that connects the left circle with the middle circle.

This is what Jeffrey Wilson, who visited the formation, said about this pathway. "I believe that this formation began to be formed with this pathway. I could clearly follow the pathway's flattened wheat into the lay of centre circle......"
It is important to notice that the pathway continued under the flattened crop of the centre circle. This genuine crop circle, the formation of which was witnessed by Rantala, had a so-called construction line in it. But what does this mean?

Summer 1998

The 1998 crop circles season was coming to an end when I arrived at Tawsmead Copse, a small woods just outside Alton Barnes in Wiltshire. It was 9th August. This copse at the foot of Woodborough Hill has been the venue of many sightings over the past couple of years. Many balls of light have been seen here. My thoughts went back to the year before, to 1997, when I witnessed an amber ball of light that floated for two minutes over the fields just beside the woods. So many people have seen balls of light here and some of these balls have even been photographed and filmed. Tawsmead Copse is a truly mysterious place.

Adjacent to the woods are a few fields and in one of these fields a new formation was discovered. It rains a lot in the South of England but for some strange reason most of the days that for me were very important and sometimes decisive, were hot. It was the same on that day at Tawsmead Copse in August 1998. For several reasons I arrived at the field later than usual. People who had been in the formation were already coming out of the field. While I was walking towards them, I saw none of the usual happiness on their faces. Even before I could ask them anything about this newly discovered formation, one of them looked at me and said: "It is beautiful. Sevenfold geometry, but unfortunately it is a hoax. You'd better go back. It is all a fake. Don't waste your time. It is all made by humans."

These remarks really surprised me and I asked them why they thought this crop circle was a hoax. "There are many pathways under the flattened crop. Lines. Construction lines. It is obvious that first some kind of basic pattern was laid out and subsequently the crop was flattened. There couldn't be a clearer proof of human activity", was the reply.

I stood there for a moment in silence. The people didn't wait for any comments from me and had already moved on. I didn't know what to think of this. My mind went back to the year before, to 1997. That year I had seen these so-called construction lines as well: pathways of crop, about a foot wide, laying under the flattened crop of the formation. In 1997 I had seen this feature in a crop circle near Silbury Hill. I had not paid a lot of attention to that particular one because it was another fractal, a so-called Koch fractal, and I didn't want to get entangled in numbers and fractals again. While I was standing at the field near Tawsmead Copse, this Koch fractal crop circle of 1997 came very vividly to my mind again and I suddenly realised the huge importance of that formation. How could I have ignored this crop circle? I couldn't say a word, I was so surprised. Why didn't I realise before how significant this Koch fractal had been? My mind went back in time to the year 1997.

Silbury Hill, UK, 1997

When I had arrived at Silbury Hill on 23rd July 1997 and looked at the crop circle that had just been discovered, I was overwhelmed. Not so much by the shape, because that was hard to recognise. No, I was overwhelmed by the amount of flattened crop. Although the crop circle was big but not spectacularly huge, every bit of it was flattened and that was a lot.

I walked around on this enormous area of flattened crop. After a while I began to realise that the shape of the formation resembled a six-pointed star, a so-called Star of David. I was surprised by that, because the centre of the formation was a circle. Walking from the centre of the formation to the perimeter, the central circle in some way was transformed into a six-pointed star. Around this six-pointed star were numerous little circles laying in the field. I was amazed.

Then I stumbled on something that confused me. Under the flattened crop I saw what looked like a foot-wide pathway of flattened crop going in a different direction from the general lay of the crop. This was the first time I had come across so called "construction lines".

On first sight, these lines did make not much sense to me. But, after following and analysing them in the field, I came to the unavoidable conclusion that some construction lines were missing! I made notes of these underlying pathways, these construction lines, and I left it there.

It took over a year, until I was about to enter the Tawsmead Copse formation, before I understood the importance of this crop circle, the construction lines and especially the "missing" lines.

Let me explain. When you take a close look at this formation from the air, you will understand why the construction lines didn't make sense at first and why I thought some of them were 'missing'. Let us have a look at this formation. There were a lot of little circles around the formation, which were of great importance but which, for reasons of 'readability', are left out of the diagrams.

The main body of the formation resembled a Star of David and can easily be constructed, as can be seen in the diagram.

 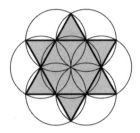

But let me make clear that the crop circle we are looking at was not a Star of David, it is not even related to it. No, it was a Koch fractal and the difference between a Star of David and a Koch fractal was expressed in the construction lines, which made them confusing at first but in the end, so special. Look at the diagrams and see the difference between the two. On the left is a Star of David, on the right is a Koch fractal.

A Star of David consists of two equilateral triangles superimposed on each other. A Koch fractal is basically a triangle, with three triangles attached to the sides and more triangles attached to their sides, and so on and so on.

 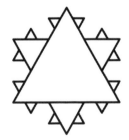

In the Silbury Hill crop circle, the smallest triangles were replaced by small circles. That is why these small circles were so important. Notice the six construction lines of a Star of David compared to those of a Koch

fractal. In a Koch fractal there are three lines less! There are three lines 'missing'.

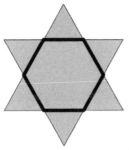 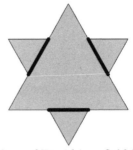

This is important, because while making a Star of David in a field is not so hard, making a Koch fractal is so much harder. And the formation at Silbury Hill was a true Koch fractal. There were only three underlying pathways or construction lines instead of the six that would have been there if it had been a Star of David. Whoever or whatever made the 'Kochfractal' crop circle at Silbury Hill in 1997 knew exactly what it was doing and we know this for a fact because of the construction lines! The construction lines under the flattened crop were a representation of the shape at hand and not an aid for the construction. Again I ask you to let this sink in. The construction lines had a definite purpose, but a complete different one from that which everybody thought it was. It took another year before I realised this.

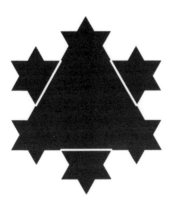

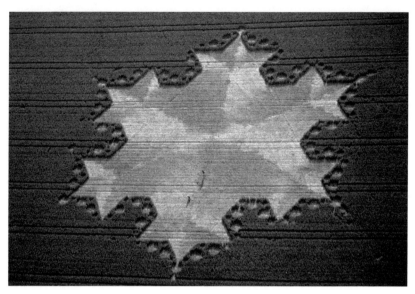

Koch fractal crop circle near Silbury Hill, Wiltshire, UK. 23 July 1997.

Tawsmead Copse, UK, 1998

There I was, at Tawsmead Copse and people were telling me to go back, to ignore this crop circle because it was man-made. They had found so many so-called underlying construction lines in this formation that in their view it was clearly a hoax. After a while I overcame my first shock. My mind had settled down. In fact, thinking back to Silbury Hill 1997 had made me really curious to see these lines in the Tawsmead Copse formation. Now I wanted to see them. I couldn't wait, I had to see them, so I rushed through the field towards the formation.

After arriving in the crop circle, it turned out that the lines were easy to spot when you knew what to look for. They were definitely there, there was no doubt about it. I made notes and a drawing of the formation including the lines and I worked for hours despite the heat. I was sweating away while following line after line. Slowly it became clear to me that this formation at Tawsmead Copse was probably the most important formation I had visited up until then. The more lines I followed, the clearer picture in my head became and with that, the realisation of how significant the crop circle was.

The Tawsmead Copse formation has had a lot of attention since it came down on 9th August in 1998. It was one of the first crop circles based on sevenfold geometry, something people thought was impossible to hoax.

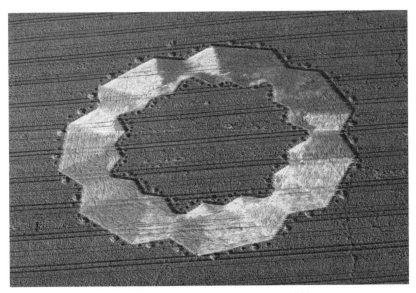

Tawsmead Copse near Alton Barnes, Wiltshire, UK. 9 August 1998.

Others thought otherwise. My reconstruction of this formation will show why I came to the conclusion that the construction lines that were found were the ultimate proof of non-human activity. The construction is not that complicated. Here I just show the most important steps.

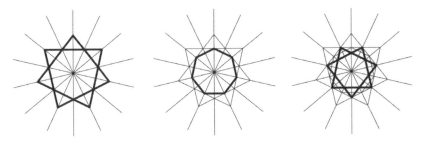

Starting off with a big heptagram, I constructed a smaller heptagram that exactly fits into the bigger one. Besides that, I constructed a heptagon that also exactly fits in the bigger heptagram. The third diagram shows how a heptagon is constructed in the smaller heptagram.

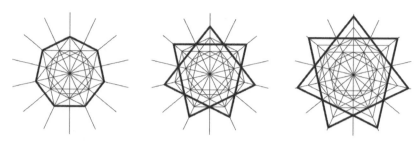

A few steps later, I constructed another heptagram and yet another. With this the reconstruction of the 1998 Tawsmead Copse formation is virtually ready. Taking out the appropriate lines completes the reconstruction. The result looks as follows. It has to be said that the original formation contained numerous small circles. These are left out in the reconstruction.

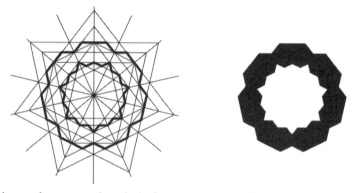

As you have seen the whole formation is based totally on heptagrams and heptagons, which are all related to each other through the construction techniques that have been used. Every element followed out of the previous element. All elements are connected by strict geometrical rules. Let us go back for a moment to 1998 when I met the people in the field at Tawsmead Copse. Those people were convinced that the crop circle was man-made because of the many construction lines that could be found in the formation. There was no doubt in their mind. But which lines were these people talking about? Where were these lines situated in the crop circle? Where could they be found?

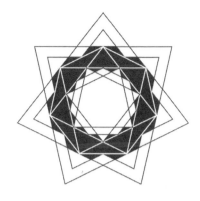

Look at the diagram on the left. It is an exact diagram of the 1998 Tawsmead Copse crop circle. The white lines in this diagram represent those construction lines. They are drawn exactly on the spots where they were found in the actual crop circle.

The diagram on the right shows the same formation but now with all the heptagrams and heptagons I used and needed to reconstruct the formation.

Construction lines accentuated by black lines.

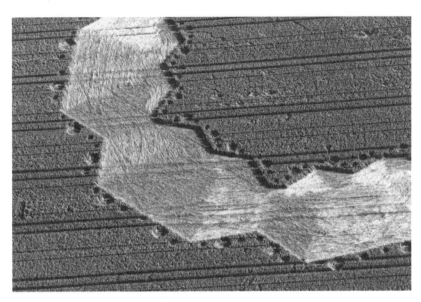

Actual under-laying construction lines

It really is astonishing to see that the lines that were found in the actual crop circle are identical to lines that I used in my reconstruction. It looks very much as if the technique I used on paper was also used in the field. But that is ridiculous. No natural phenomenon would have the need for these lines, it would just flattened the crop in one go. No construction lines, no pathways under the flattened crop.

Does this mean that the people I met at Tawsmead Copse were right after all? That in the end, this crop circle was made by human beings? No, it does not. As I said before, a natural phenomenon would never feel the need to use construction lines. At the same time I stick to my statement that this crop circle was absolutely not a joke made by pranksters. This formation was definitely not a hoax and this statement is born out by the following facts.

Take a look at the aerial photo and compare it with my diagram. All of the heptagons and heptagrams I have drawn were necessary to reconstruct the crop pattern. There was not one that I could leave out, I needed them all. Now take another look at the photo. The so-called and much discussed construction lines are even visible in this photo. Look again and notice that many of the lines that I used, lines that I needed to reconstruct

the formation, could not be found in the actual crop circle. Of all the heptagrams and heptagons I needed to reconstruct the formations, only two were actually present in the field. If human beings had made the 1998 Tawsmead Copse formation using the same construction techniques I used on paper, then many more so-called construction lines would have been found in the field.

Take another look at my diagram. This diagram shows that some construction lines would even have been found in the standing crop! It is important to realise that the construction techniques that I used on paper cannot be repeated in the field without leaving their traces. For instance, look at the large number of seven-fold stars that I needed and that can no longer be found in the end result. It is absolutely impossible to erase those figures in the fields. Look again at the aerial photo and see for yourself that there were no heptagrams and heptagons and no construction lines in the standing crop. Think about this.

The underlying construction lines found in the crop formation indicate that exactly the same construction techniques that I used were applied when this formation was created! But on the other hand the absence of many other construction lines indicate that these construction techniques were not used!

Of course, one might claim that humans can actually mark out those large figures in the fields - like for instance the large seven-fold stars - without leaving a trace. Although this is quite unlikely to be true, let's give them the benefit of the doubt. Just for now... Suppose it is indeed possible to construct those formations without leaving a trace. This means one can make absolutely fascinating formations: formations without underlying construction lines!

From a human point of view, those are the ultimate formations. In other words, if humans are able to leave out construction lines, they will definitely do so. If they can make large seven-fold stars without leaving any construction lines, they will **never** make smaller seven-fold stars, which do show construction lines!

If this particular crop circle was made by humans and those humans do not need construction lines, than none would have been found. But there were definitely construction lines present under the downed crop. On the

other hand if this crop circle was made by humans and those humans do need the aid of construction lines, then we would have found them throughout the field. Even in the standing crop. See my diagram. But there were no lines present in the standing crop. This is a classic catch 22 situation! Either they needed lines and we would have found many, or they didn't need lines and we would have found none.

This is the catch-22 situation.
1. Either human beings can make large seven-fold stars without leaving construction lines, but that means we would not have found **any** construction lines in the formation at all. However, we did find them!
2. Or human beings cannot make seven-fold stars without leaving construction lines, but that means we should have found the construction lines in the large seven-fold stars as well. However, we didn't. They weren't there!

Back in 1998, when I walked through this crop circle on that very hot day, I realised how significant those underlying lines were. Those lines present in the field and which everybody said were proof that the crop circle was man-made, turned out to be the ultimate proof that the formation was not a hoax. Hoaxers need many lines or no lines at all. And if you do not need lines, you are not going to use them. Those lines that were condemned by so many, suddenly became so important.

The moment I realised this, I was stunned. On one hand it gave me a pleasant feeling but at the same time I was puzzled as well. Why were there lines in the field at all? The catch 22 situation excluded human activity, but it didn't answer this question which kept returning to my mind: why there were lines in the field in the first place?

A natural phenomenon would not have needed these lines, but the lines were nevertheless there. It could mean only one thing. Those lines, those very same lines that proved that the formation was not man made, proved also that the crop circle was not caused by some natural phenomenon. Realising this really took me aback. Something or someone was at work here and it was neither human nor nature. This thought had already come to my mind while studying the construction points, but now it was so much stronger.

In 1997 I had come to the conclusion that the ring-element in the Etchilhampton crop circle was added to that formation for a purpose. A lot of thinking had gone into the design, size and placing of this ring, whoever or whatever had thought this out. Now I was confronted with the same kind of situation. Whatever or whoever had made the 1998 Tawsmead Copse crop circle had added something to it in such a way that it was proof that on one hand it was not man-made and on the other hand it was not caused

by nature either! A natural phenomenon would never have made the formation the way it was found, it would never had needed the lines. As with the Etchilhampton ring, I could only come to one conclusion. The 1998 Tawsmead Copse crop circle was made by something that went through a lot of thinking.

Some elements were added to the formation intentionally. The formation could have been made without the lines, but the lines were there and I was sure that these lines were added on purpose. The 1997 Etchilhampton ring indicated that the phenomenon was well aware of human shortcomings. In a way it looked as though whoever or whatever had made that crop circle, had taken into consideration the fact that we humans could only reconstruct that pattern with the aid of a compasses.

Again I stared at the diagram of the 1998 Tawsmead Copse crop circle. Here was a similar situation. Again it looked as if whoever or whatever had made the formation, had taken into consideration that we humans could only reconstruct that pattern with the aid many, many heptagrams and heptagons. But now it went even further.

Not all elements we humans would have needed were put into the field by the phenomenon. For this, the phenomenon had to do even more thinking than with the Etchilhampton ring. Jokingly it came to my mind that I would have done the same thing if I had been the phenomenon. I could not suppress a little smile, but this smile disappeared as quickly as it had appeared. My mind, my human mind would have come up with the same ideas as the phenomenon. I realised that all the thinking the phenomenon was doing, resembled so much human thinking, human logic. I was silent for quite some time. Was the phenomenon "us"? Are "we" the phenomenon?

No matter how I looked at it, I had to come to the conclusion that parts of the geometry used indicate that humans were involved in some way in the making of the formations. Not in a physical way, but human intellect or at least the human way of thinking was involved in the construction of numerous crop circles. But at the same time, these crop circles were NOT made by humans; at least not in the traditional physical way. Human beings did not make the formations, but the techniques that were used were based on human logic.

The more I thought about this, the more inconceivable but also the more unavoidable the conclusion became.

Construction lines are not a strong indication of human activity. On the contrary. Construction lines are the ultimate proof of intelligent but non-human involvement. That is, non-human on the physical level.

As Sherlock Holmes said: "When you have eliminated the impossible, whatever remains, however improbable, must be the truth."

I advise you to put this book away for a while. Take your time to digest all the above. The only possible conclusion is so far-reaching, that it needs time to sink in. Give it that time.

Mystical Wiltshire with Woodborough Hill

6. More Than One Geometry

Introduction

The formations I have shown so far, were each based on one kind of geometry: three-fold geometry, four-fold geometry, etc. By far the greatest number of crop circles fit in one of these categories. But there are exceptions and these exceptions are very special by themselves. Although there are not many of them, the few that have been found were extremely powerful. One would expect that a combination of different kinds of geometry in one design could be likened to music played out of tune - very awkward. But this was not the case. On the contrary, they belonged to the most powerful designs found.

Cherhill, UK, 1999

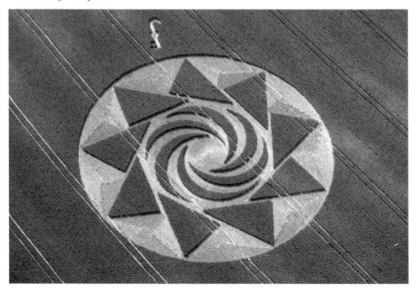

Cherhill, Wiltshire, UK. 17 July 1999.

On 17th July 1999 I climbed Cherhill near Calne. It is one of those hills with a white horse carved into its chalk. I had been there before on exactly the same day, 17th July, the previous year. On that July day in 1998, I was with Janet Ossebaard in the formation that had come down at the foot of the hill, when she discovered for the first time dead flies in a crop circle. Those dead flies that were stuck to the seed heads with their tongues had made a deep impression on me. And not only the flies. The formation itself was very peculiar. It was a kind of mix between perfect circles, which all had roughly the same diameter of two metres, and wind damage. On some spots it looked as if the wind damage had occurred first and then the circles had come down; on other spots it appeared to be just the opposite.

While walking up the hill in 1999, all the pictures of 1998 came vividly back to my mind again. In 1998 I had gone through most of the field in search of those mysterious dead flies, but I could find none. They were only to be found in the crop circle. Cherhill is also the place where in 1992, magnetite was discovered in a crop circle for the first time. The concentration of this magnetite, which turned out to be of meteorite in origin, was about 400 times higher than one would expect. The rest of the field showed normal values. I realised that I was walking in a truly mysterious place.

Arriving at the top of the hill I looked down at the formation that had come down that night. I was amazed. Below me lay a crop circle with six crescents in its centre. Clearly six-fold geometry. But around this centre was a nine-pointed star, so nine-fold geometry. This formation was based on six-fold geometry and nine-fold geometry at the same time. One would expect that a combination of such different geometrical bases would look awkward, but the formation was in perfect balance and full of harmony.

The diagrams below show how the centre can be reconstructed.

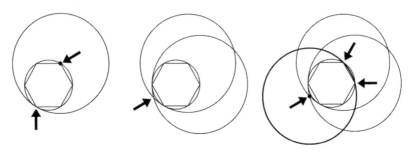

Even though I knew that it was not possible to construct nine-fold geometry, I still felt the strong urge to study this formation, to try to reconstruct it as accurately as possible. While doing that I stumbled on something really extraordinary. The method I used to construct the nine-fold geometry can be found in the appendix. Take a look at this method and notice that a six-pointed star is used for the construction. I was astonished. Such a strange coincidence that one of the best methods used to construct nine-fold geometry should involve six-fold geometry, just as the crop circle at Cherhill had demonstrated. I had the strong feeling that the Cherhill formation of 1999 was educating us in geometrical constructions. And not only on geometry, but also in many more things on different subconscious levels.

Avebury, UK, 1994

The formation at Avebury in 1994 was really extraordinary. Not only had it come down in two phases on 10th and 11th August, but it also contained geometry with some amazing characteristics. The crop circle became famous and is known as 'The Web' or 'The Dream Catcher'.

Many formations that had appeared in the late 1980s and early 1990s were studied by people like John Martineau and Wolfgang Schindler. Martineau and Schindler had mainly looked at the so-called external geometry of these crop circles. As I said in chapter one, they didn't take the formations apart, they merely added geometrical shapes to it to see if

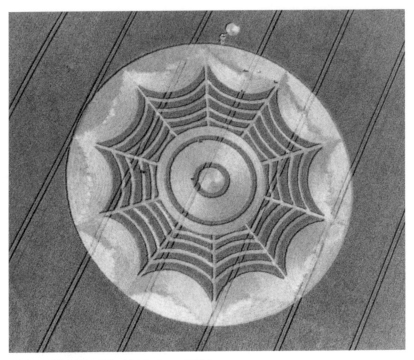

Avebury, Wiltshire, UK. 10-11 August 1994

these would fit. Schindler, especially, worked mainly with pentagrams. The outcomes were really quite staggering but when the shapes of the crop patterns changed in the early 1990s, the working methods of Martineau and Schindler could no longer be applied. The formations were beginning to look more like mandalas and no external geometry could be added anymore. The crop circle formation at Avebury in 1994 was a sublime example of such a mandala.

I had already done many reconstructions before I looked at this extraordinarily beautiful crop circle. It was a challenge I just had to take on. As usual I began by staring at the formation for quite some time. It was obvious that the formation contained ten-fold geometry or, if you break it down, five-fold geometry. After I had looked at the shape for a considerable time I suddenly got a shock.
I looked at the small ring and the bigger ring in the centre and at the shape in total. My heart began to beat faster. I recognised the relationship in size of the rings and the total shape. I grabbed a ruler and to my astonishment I saw that I was not mistaken. Two

different pentagrams fitted perfectly in the formation. The features discovered by Martineau and Schindler had not completely vanished. They had moved place but could still be found in this 1994 crop circle. I was amazed and curious at the same time. Now I definitely had to know if this formation could be reconstructed using the techniques I had developed. Although I thought that I would not be successful because my basic pattern was based on three-fold geometry, while the 1994 Avebury crop circle was based on five-fold geometry, I still gave it a try. And I am glad I did.

The diagram on the right shows how two pentagrams fit perfectly into the formation.

It took me several days to accomplish the task, but in the end I did succeed. I actually could reconstruct the Avebury formation starting with my basic pattern. During all this work I went from one surprise to the next. There were so many cases of coincidence. So many times that the three-

fold geometry I was using would connect precisely to the five-fold geometry of the crop circle. I will only show you one step here, one diagram, all the other steps and diagrams can be found on my website http://www.bertjanssen.nl/cropc/. I admit the diagram looks rather complicated but let me explain.

t took many steps to construct the 'fat circles' that can be seen in the middle of the pattern. These are needed to construct the arcs. To do this, part of the inner circles are copied and pasted at the side. Notice that the construction point needed to accomplish this operation is sitting exactly on the perimeter of the formation. Had the outer edge of the formation been a little closer to the centre, this construction point would have been in the standing crop! But it is not. And the distance of the outer edge to the centre was also exactly the right one to enable one of the pentagrams to fit. Again we see how two different geometrical bases come together and fit precisely. This is really a very strange coincidence. Or is it not? Notice also how both sets of rings are touching/overlapping. This is another extraordinary coincidence and has nothing to do with the rules of geometry. But most fascinating of all are the points where the circles do intersect! First of all these points are lying exactly on one line and secondly, and this is really fascinating, this line goes exactly through the geometrical centre of the equilateral triangle. So the overall formation, which contains five-fold geometry, is interlocked with the three-fold geometry of the equilateral triangle inside. This triangle is also part of the basic pattern out of which so many crop formations can be reconstructed. If you study all the construction steps you will see how this array of coincidences is too much to be true.

After I had finished the reconstruction I sat back and I realised I had come across a truly fascinating event. The 1994 Avebury crop circle incorporated two worlds: the world of Schindler and Martineau by means of the perfect fitting pentagrams, and the world of my basic pattern. In coming together in one crop circle, these worlds were interlocked. It was almost as if they were saying: "Look, we are about to take the next step"; and that is exactly what happened during the following years.

7. Landscape Alignments

Introduction

After many years of making drawings and reconstructing crop circles I had become convinced that there was far more going on in the patterns found in the crop than their outer shapes suggest. Not only are the crop circles a genuine phenomenon, i.e. that most crop circles are not made by hoaxers, I also had come to the conclusion that I was dealing with much more than just a phenomenon of nature. There had to be some sort of intelligence involved. The construction points I had found had given me this idea and my discoveries concerning construction lines had reinforced these thoughts about this intelligence.

Since that time a new question had arisen. Why? Why do these patterns appear in the fields? I could not belief that they appeared without any reason, but what was that reason? If there was an intelligence involved, and by now I was convinced that there was, then why would this intelligence create these shapes in the crop? What was the motivation in doing so?

The most obvious answer to this question was that the shapes were some sort of communication. This felt right to me. I believed strongly that the patterns were actual forms of communication. But with what or whom was this intelligence communicating? Of course I wanted it to be there for us human beings and for it to be trying to talk to us by means of these crop circles. But could any proof be found for this. I had been worried many times that my research was driven by wishful thinking and self-fulfilling prophecies, that I was just "seeing things". Perhaps I wanted this communication so badly, that I would see it even if there was nothing there to be seen.

Then I realised that during all the years of studying crop circles I had come across a most peculiar feature, which I thought at first was just a strange coincidence. Because I had always been so focused on the shapes and geometry of the patterns, I had neglected this feature. But, as I had experienced so often by now, there is no such thing as coincidence. I should have known that this particular feature was no coincidence at all, but was there for a very good reason.

Again the nervous tension in my stomach appeared. I immediately got out all my drawings and diagrams to see if I was right. I found that the feature was as I remem-

bered it and was located at the places where I remembered it to be. Looking at the diagrams I knew for sure that we people do play a role. Whether we will it or not, part of the crop circle phenomenon has to do with us human beings. The nervous tension had changed into a feeling of satisfaction. We are not random observers and I felt good about it.

How could I be so sure? So far I have talked about the many peculiarities of crop circle geometry. I have pointed out how intricate this geometry is; why it shows that there is some form of intelligence behind the creation of the crop circles. But there is more. There are strong indications that this intelligence is trying to interact with us.

Let's have another look at the Chilcomb Down formation of 1990.

Do you remember how the dark constructed circle, the circle added by Wolfgang Schindler, precisely touched two 'tramlines' that seemed to have nothing to do with the formation? The tramlines are the tracks used by the farmer to drive his tractor through when he sprays the field. Every farmer uses different machinery, therefore the distance between the so-called tramlines is a human factor and differs from field to field depending on which farmer is working that particular field. The 1990 crop circle at Chilcomb Down was the first formation I had come across that had this strong connection to a human element and my first thought had been that it was just a coincidence that the added circle touched the tramlines. Later on I found many more crop circles with this "coincidence" of added, virtual elements touching the tramlines.

Oud-Beijerland, the Netherlands, 1998

This simple but, as you will see, very interesting crop circle appeared on 8th August 1998 near Oud-Beijerland, in the Netherlands. Despite being a simple design on first sight, the formation was measured meticulously by Roeland Beljon and Nancy Polet. And we have to thank them for that. First of all it turned out that the size of some elements of this formation were determined by other elements, as I have showed you many times before.

Look at the rings in the right diagram and notice how the size of the outer perimeter is determined by the size of the inner perimeter by means of a virtual square. And the size of the little circle within the right ring is determined by the outer perimeter of the ring by means of an isosceles triangle.

Not only were the sizes of some elements fixed by other elements, but also the placing of some elements was determined by the placing of other elements. This can be seen in the left diagram. In the right diagram we see the so-called "coincidence" with the tramlines happening again. The size of the big circle is determined by its distance to the tramline, otherwise the virtual triangle would not have fitted. And the placing of the little circle on the right is determined by the bigger circle by means of

83

the virtual circle circumscribing the virtual triangle. So in a way the little circle is also connected to the tramlines.

The diagram on the left shows how the size of the bottom circle is fixed by the size of the big circle. Also its placing relative to the tramlines is determined in the same way. Again and again that same "coincidence". Also the fact that the same virtual triangle and circle that fix the size and placing of the bottom circle, fix the inner perimeter of the left circle as well. It also determines the relative placing of this circle to the other tramlines. Isn't this fascinating! There are even more of these peculiar relationships, which can be seen in the right diagram. There is no way that these are all just cases of coincidence. It is beyond doubt that a human element, in this case the tramlines, plays a prominent role in this formation.

It took some time before it had all sunk in. I tried to imagine how, if I decided to construct the figure, I would go about it:
a little circle surrounded by a ring set in such a way that an isosceles triangle circumscribing this little circle, exactly defines the inner and outer perimeter of the ring, whereby a square drawn around the inner perimeter also just touches the outer perimeter. Now construct a bigger circle in such way that a circle circumscribing an equilateral triangle that is drawn around the big circle, just touches the little circle, and that a circle circumscribing an equilateral triangle that is drawn around the little circle, just touches the big circle.
This is nearly impossible to do. And these were only the very first steps involved in the construction of the Oud-Beijerland crop circle. I was really amazed when I realised the far-reaching consequences of all that could be found in this one crop circle.

I want to show you one other example of how crop circles are aligned to tramlines. This particular formation that appeared on 13th July 2003 near Wilhelminaoord in the Netherlands, shows the intriguing combination of elaborate geometry and its fitting within the different elements of the field. At first glance the formation looks straightforward and simple, but there is a lot of hidden geometry which makes this formation very special.

There were two distinctive elements in the field that I want to point out to you. First the bottom tramlines (tractor tracks) were not exactly parallel to the middle ones. This is very uncommon. Even more uncommon is the fact that the distance between the top tramlines and the middle tramlines was much greater then the distance between the bottom tramlines and the middle tramlines. Both factors, which are highly uncommon, play an important role in the geometry of the crop circle.

Look at the diagram above and notice how one of the tips of the pentagram just touches a tramline while another tip also touches a tramline. Notice also how one side of the pentagram is exactly aligned to the North. You can only construct one pentagram in this field that meets these conditions. Only one pentagram that has two tips touching a tramline and one side aligned to the North will fit in this field. You could say that the con-

ditions of the field, that is the placing of the tramlines, dictate the size and placing of the pentagram. This is a very important feature to note.

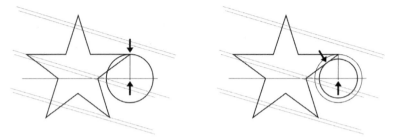

Draw a horizontal line through the pentagram as shown in the diagram. Now draw a line starting at the right tip of the pentagram and exactly perpendicular to the horizontal line. Construct a circle with its centre at the intersection of the horizontal and vertical line and with its perimeter just touching the right hand tip of the pentagram. See diagram on the left. Draw another circle in the same way, but now just touching the side of the pentagram. See diagram on the right.

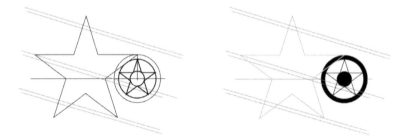

In the smaller circle we can construct a new pentagram and within this figure we can construct a circle. This is shown in the diagram on the left. The right hand part of the formation is reconstructed as can be seen in the diagram on the right.

Notice how the smaller pentagram with the little circle also exactly touches a tramline.

Now draw a line starting at the left tip of the pentagram and exactly perpendicular to the horizontal line. Construct a circle with its centre at the intersection of the horizontal and vertical lines and with its perimeter just going through the intersection of the vertical line and the tramline. See diagram on the left. With this the crop formation is fully reconstructed. See diagram on the right.

The perimeter of the circle on the left touches the intersection of the vertical line and the tramlines. This is because of the fact that the bottom tramline is not exactly parallel to the middle tramline. If they had been parallel, the tramlines would have gone through much more of the circle on the left. It looks as if there is an interaction between the crop circle and the tramlines.

If this had been the only case, one could argue that it is just a coincidence. However, not only do the tramlines play a major role with the left circle and the virtual pentagram, there is also a connection between the virtual pentagram, the ring around the circle on the right and the top tramlines. Do remember that the difference in distance between the different tramlines is very uncommon, but here they fit the pattern exactly, as can be seen in the diagram below.

The two virtual pentagrams are of equal size. The pentagram on the right is placed in such a way that it touches the ring of the crop circle at two different places. An extension of the left pentagram is precisely touching the tip of the right pentagram, which in itself is already a strange coincidence; but the spot where they meet is touching the top tramlines exactly. Again this was only possible because these top tramlines were laying a little further away than the bottom tramlines. But is this connection with human elements always limited to tramlines? No, it is not, as you will see.

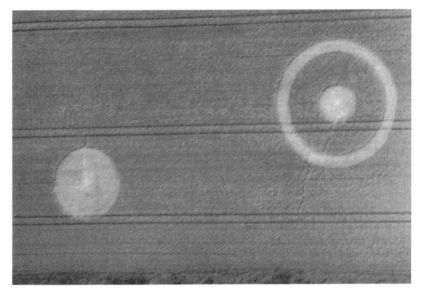

Wilhelminaoord, Drenthe, NL. 13 July 2003.

A couple of months before I analysed the Wilhelminaoord crop circle, I was in Wiltshire, England. 4th August 2003 was again a very, very hot day. In fact it was about the hottest day in England for over a hundred years. That day I walked slowly up to the top of Morgan's Hill - situated between Devizes and Avebury - to visit a crop circle that had been discovered the day before. It was a demanding walk because of the heat, but worth the effort as it turned out, although not all the people I met in the formation were impressed by the pattern.

In their opinion, the geometry was not perfect and they referred to a very similar formation that had appeared in 2001 near Cambridge. I had been in that formation near Cambridge as well and knew that those people were right. The geometry of the Cambridge crop circle had been frightening accurate while the geometry of the formation

on Morgan's Hill was far from precise.
I walked slowly around battling with the heat, when I noticed a remarkable feature. The crop circle consisted of many lines or rays of flattened crop. These lines were about 15 centimetres wide and they all came together on one spot. Standing on this spot where these lines met and looking exactly over a the little tuft of standing crop in the centre of the central circle and precisely through one of the rays, I could see a two-metre high stone monument that stood about a hundred metres away from the crop circle. The crop circle was unmistakably aligned to this monument! The nervous feeling in my stomach was back!

Immediately the formation of North Down came to my mind. Earlier that year, on 6th July, a crop circle had been found on the North Down, about two miles north of Morgan's Hill. Because of its design, the formation itself was already peculiar, but most remarkable was the fact that the crop circle lay exactly in a line with four Neolithic burial mounds known as tumuli. I had not really paid any attention to this fact because once again, I thought it was some kind of coincidence. I have made this

stone monument | (point A)

Linda Moulton Howe sitting next to the tuff of standing crop in the centre of the central circle of the 2003 Morgan's Hill formation. In the background the stone monument.

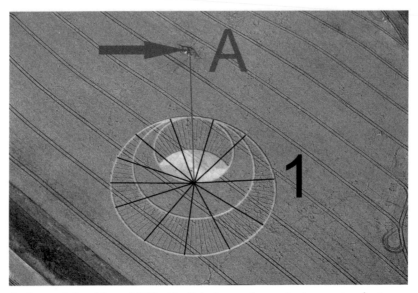

1. *the crop circle at Morgan's Hill with all the lines coming together in one point.* **A.** *the stone monument to which the crop circle is aligned.*

mistake so many times. But while standing in the Morgan's Hill formation and looking at its alignment with the stone monument, I realised that the North Down alignment with the tumuli was not just a fluke. Neither of the formations were aligned to natural elements in the landscape, they were aligned to elements made by humans. At Morgan's Hill it was the stone monument, at North Down it was the four Neolithic burial places. This intrigued me to such an extent that it kept my mind busy for the rest of the day.

That evening I went out to visit some Italian friends. I told them what had happened earlier that day. They became so fascinated that they took out a map to have a look at the situation. While we all studied this map I got a shock. I looked at the four burial places on the map and then looked at the virtual line that was connecting these tumuli and followed this line in the direction of Morgan's Hill. I couldn't believe my eyes.

I took a ruler and drew this virtual line on the map. I was not mistaken. The line that connected the four tumuli and with that the North Down crop circle, passed exactly through the same stone monument on Morgan's Hill. I extended the line in the opposite direction and noticed that yet another crop circle was connected by the same line. Three miles further

North Down, Wiltshire, UK. 6 July 2003.

North Down formation of 2003 and the four tumuli.

2. *the North Down crop circle of 2003 and* **B.** *the four tumuli with which it forms one line.*

north, the crop circle at Avebury Trusloe was also part of the connection. I was amazed. This time I would not make the mistake again of thinking that this was just a coincidence. There was no escape. The three crop circles were aligned to a human element, and this alignment was established on purpose. There was no doubt in my mind anymore. The connection with the tramlines had already shown that there was likely to be an intended interaction between the phenomenon and us humans. Now, after what had happened on Morgan's Hill, to my mind it was not just likely anymore, it was a certainty. There was a definitive relationship between us and the phenomenon. We were not just random observers.

Later that year I learned that a similar alignment had been found near Serpent Mound in Ohio, USA. This kind of news did not come to any surprise to me anymore.

1. *the crop circle at Morgan's Hill*
2. *the crop circle at* North Down
3. *the crop circle at Avebury Trusloe*
A. *the stone monument*
B. *the four tumuli*
C. *Avebury*

8. Conclusion and some personal reflections

Conclusions

In 1995 I walked through the crop circle near Winterbourne Bassett and I was captivated by it. The way the crop was laying, the shape, the precision of it all. I could not get over it. After I left the formation I even climbed on top of my car to get a better view. I was so much impressed. Then when I was just about to leave, the farmer arrived and together with him, I went back into the formation again. I could not get enough of it. There and then I thought my fascination was caused by the fact that this was the first real beautiful crop circle I had ever seen in my life. Now I know it was not that simple.

In the 1995 Winterbourne Bassett formation I also got, for the first time, that strange nervous feeling in my stomach, the feeling that indicated to me that there was far more to crop circles than just bent grass as Michael Glickman had once described the crop circles to me.

The journey had started, there was no way back anymore, and what a journey it would become.

First of all, I came across the work of John Martineau and Wolfgang Schindler. They showed, beyond a shadow of a doubt, that the patterns found in the fields were not just random shapes. I was fascinated by their work. But over the years the shapes of the crop circles had changed and the working methods of Martineau and Schindler could hardly be applied anymore. I decided to do my own research and started to look into the geometry of the crop circles that resembled mandalas.

I found that there was a basic geometrical pattern hidden in the many crop circles that I studied. Although the crop circles had changed shape since the time of Martineau and Schindler, they had not lost their geometrical secrets. They merely had moved from the outside towards the inside.

Then on 1st June 1997 I received an email telling me a new formation had been discovered near Winterbourne Bassett. Again Winterbourne Bassett.

A beautiful formation full of harmony and in perfect balance. The formation was, as were so many other crop circles, possible to reconstruct using the basic pattern as a starting point. Everything fitted. All elements present were of the correct size and they were all placed at exactly the correct spots. But something didn't make sense. One element was missing. One crucial element, vital for the reconstruction on paper, could not be found in the actual crop circle in the field.

In later years it turned out that this was not an isolated case. On the one hand the crop circle phenomenon was following exactly the same construction techniques that I used, but on the other hand it would suddenly skip some steps and after that, it would continue using the same technique again. I could do this as well, but only on paper.

I could rub out elements I did not need anymore. But this was impossible to perform in a field. You can not make the downed crop stand again. But how could nature achieve this? Or was it not nature we were looking at? Was the crop circle phenomenon not a natural phenomenon?

The first time this thought came into my mind I was shocked. I remember how I tried to rationalise this option away. I tried to convince myself that since we humans are part of nature, perhaps nature itself could use the same "construction" techniques as we humans do. And nature is of course capable of skipping steps, I told myself.

Only a couple of weeks later a crop circle appeared near Etchilhampton in Wiltshire, England. In early August 1997 I stepped into the ring of flattened crop that lay around this beautiful formation. When I reconstructed this pattern later on, it was this ring that really blew my mind. The ring was positioned precisely at such a spot that it avoided so-called construction points located in the standing crop. Why was there an element in this formation that we humans need in order to avoid a certain situation? And this situation only happens because we humans use a set of compasses to make circles. It looked as though whoever or whatever had made this crop circle, had taken into consideration the fact that we humans can only reconstruct these patterns with the aid of a mathematical instrument. Something or someone had taken our shortcomings into consideration. Something or someone had done a lot of thinking. I could not come to any other conclusion. This all went far beyond a natural phenomenon. Nature doesn't think. But if it is not nature, who or what is doing this thinking? About a year later the phenomenon itself would provide an answer to this question.

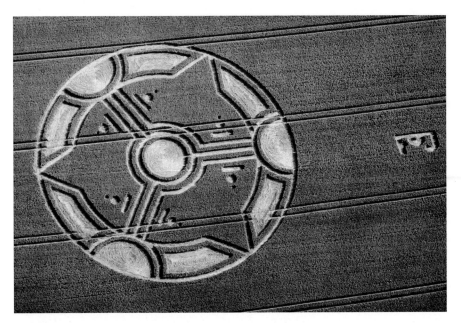

Liddington Castle, Wiltshire, UK. 21 July 1999.

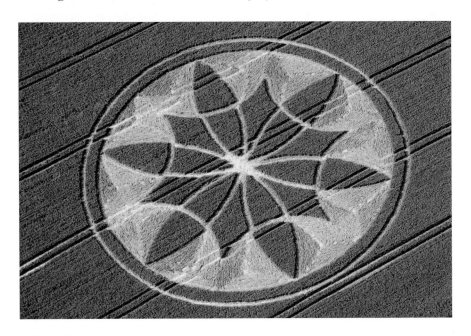

Milk Hill, Wiltshire, UK. 1 July 2000.

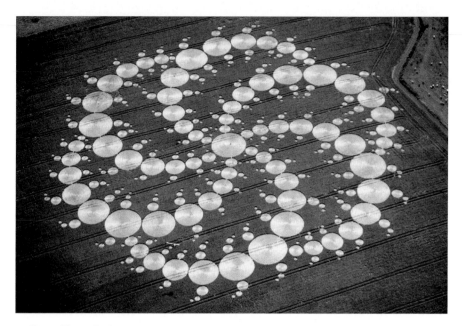

Milk Hill, Wiltshire, UK. 13 August 2001.

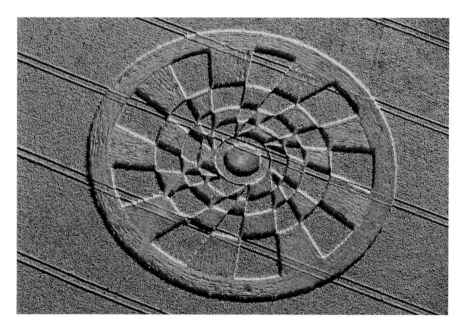

Milk Hill, Wiltshire, UK. 24 June 2003.

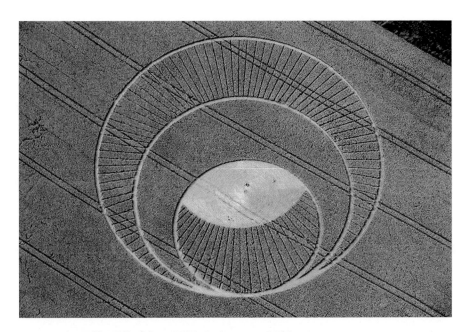

Morgan's Hill, Wiltshire, UK. 3 August 2003.

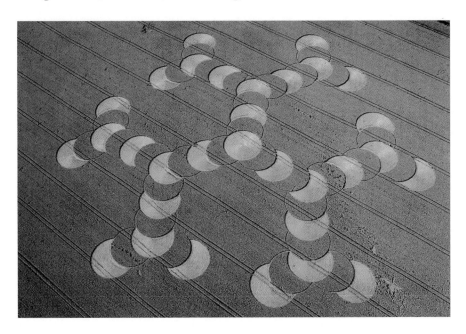

North Down, Wiltshire, UK. 10 August 2003.

Roundway, Wiltshire, UK. 31 July 1999.

Shaw Ho, Wiltshire, UK. 28 July 2001.

Silbury Hill, Wiltshire, UK. 24 July 2000.

South Field near Alton Barnes, Wiltshire, UK. 22 July 2002.

Windmill Hill, Wiltshire, UK. 15 July 2001.

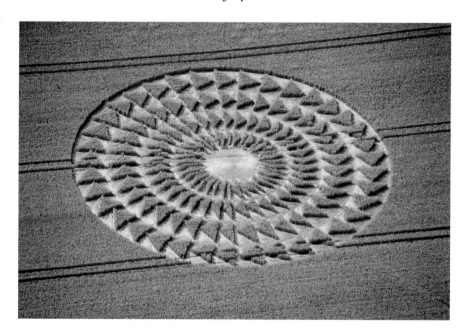

Windmill Hill, Wiltshire, UK. 2 August 2002.

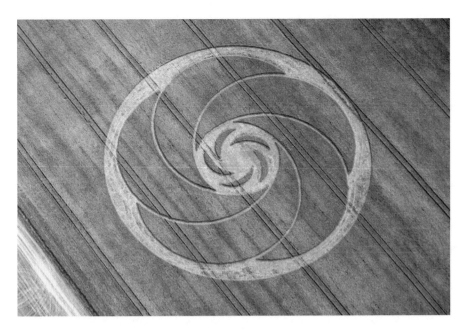

Windmill Hill, Wiltshire, UK. 22 June 2003.

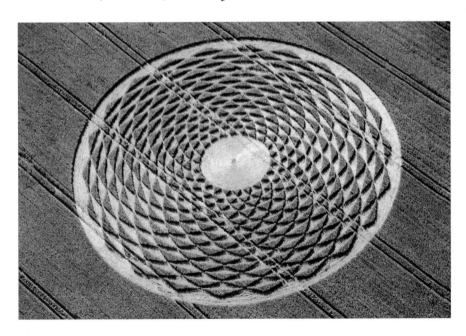

Woodborough Hill, Wiltshire, UK. 13 August 2000.

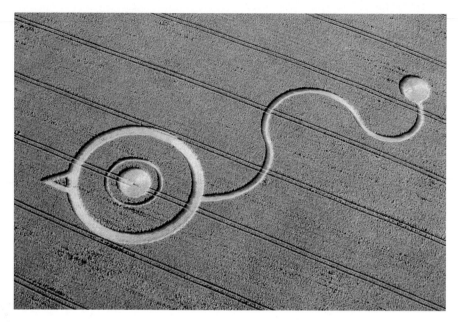

Woodborough Hill, Wiltshire, UK. 24 July 2003.

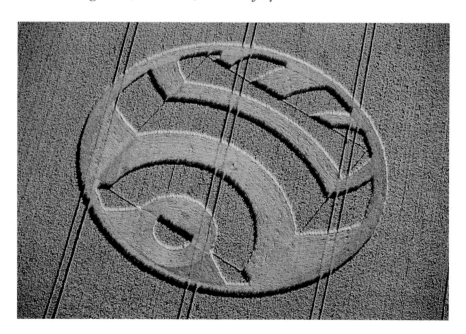

Woodborough Hill, Wiltshire, UK. 14 July 2003.

The answer lay in the construction lines in the 1998 Tawsmead Copse crop circle. Those lines, present in the field, that everybody said were proof that this crop circle was man-made, turned out to be the ultimate proof that the formation was not a hoax. And not only that. Those lines, those very same lines that proved that the formation was not man-made, proved also that the crop circle was not caused by some natural phenomenon. A natural phenomenon would not have needed these lines, but the lines were there nevertheless. Something or someone had been at work and it was neither human being nor nature.

Only one conclusion is possible. The 1998 Tawsmead Copse crop circle was made by an entity that put a lot of thought into it. Some elements were added to the formation intentionally. The formation could have been made without the lines, but the lines were there and I was sure that they were added for a purpose. The formation was made by some form of intelligence.

I remembered how it came to my mind that I would have done the same thing if I had been the entity. My mind, my **human** mind would have come up with the same ideas as the entity. It had already happened with the Etchilhampton ring but it was not until 1998 and the Tawsmead Copse formation that I realised that all the thinking the entity, the phenomenon was doing, resembled so much human thinking, human logic.

No matter how I look at it, I have to come to the only conclusion possible that parts of the geometry that has been used, indicate that humanity is in a way involved in the making of the formations. Not in a physical way, but in the human intellect or at least the human way of thinking, the human mind was involved in the construction of numerous crop circles, but at the same time, these crop circles were NOT made by human beings. At least not in the traditional physical way. Humans did not make the formations I had studied, but the techniques used were based on human logic.

Many books have been written about the crop circle phenomenon. This is one of them. Of all these books only a very few have asked the simple but so important question as to whether these patterns in the crop are meant for us human beings. I had asked myself that same question some time ago but it took a long while before I realised the answer had already been given many years before, by the phenomenon itself.

On 4th August 2003 I walked through the crop circle on Morgan's Hill in Wiltshire, England. The crop circle consisted of many lines or rays of flattened crop, which all came together on one spot. Standing on that spot and looking exactly over a little tuft of standing crop in the centre of the central circle and precisely through one of the rays, I noticed how the crop circle was aligned unmistakably to a stone monument that stood a hundred metres away from the formation.

Immediately the North Down formation of that same year came to my mind. That formation was aligned to four Neolithic burial mounds. Later on I found that the North Down formation was not only aligned to the tumuli but also to the stone monument at Morgan's Hill. And it turned out that even a third crop circle was aligned to this monument. They were all aligned to a human element in the landscape.

For decades crop circles had been aligned to tramlines and I had always ignored this fact because I thought it had been a coincidence, a fluke. The Etchilhampton ring and other formations with a similar feature had already indicated that the phenomenon took us humans in consideration. But it was not until Morgan's Hill 2003 that I became sure about the definitive relationship between us and the phenomenon. We were not just random observers.

The patterns in the field are not just fancy decorations in the landscape. Many people are affected by the shapes, not only on a conscious level, but also on a subliminal level.

Because of my professional background as communications consultant and trainer I have been involved in many advertisement campaigns. I know all about the power of advertising, what it can do to consumers. I know about the power of company logos, the power of shapes in general. It was this knowledge that made me realise that perhaps the Winterbourne Bassett formation had had a much bigger influence on me then I first thought.

When this idea first came to my mind it seemed ridiculous. My ego didn't want it to be true. But my professional background forced me to give this option serious consideration. Now, so many years later, I am convinced that the shape of the Winterbourne Bassett formation has played a decisive roll in my decision to study the geometry of crop circles. The urge I felt to start analysing the patterns was partly triggered by the symbol that lay in the crop in 1995 just out side Winterbourne Bassett.

And it didn't stop with this crop circle. Many other formations have had a similar influence. And they didn't influence just me. Countless other people who have seen the symbols, who have looked at the shapes, were influenced by them on many levels.

On some occasions we will be aware of the influence the crop circle patterns have on us, but most of its work is done on subliminal levels. We are not consciously aware of its influence, but it is there nevertheless. That is why I gave this book the title *"The Hypnotic Power of Crop Circles"*. I do not mean that hypnosis is a form of negative manipulation. The crop circle shapes work deep inside us in such a way that it enables us to do and feel things that we were unable to access before.

Read the section with my personal reflections in order to understand why I think the shapes do influence us in a positive way and why it is not negative manipulation.

Crop circles. One of the biggest mystery of our times. They are obvious not the work of pranksters and practical jokers. They are also not a natural phenomenon. Nature doesn't think. But the thought, whoever or whatever is thinking it, has a very strong resemblance to the way in which we humans think. It is very much as if the phenomenon is just another part of ourselves. On one hand we are not responsible for the shapes in the crop, on the other hand we are.

What about the "farmer". You remember the farmer with the sledgehammer? I have come to the conclusion that the farmer hammers the shapes in the fields for a very good reason. It is not galactic vandalism. The shapes are meant for us human beings and serve a definite purpose. The farmer is trying to tell us something about himself and at the same time he is trying to accomplish something. He is telling us who he is and showing us what our capabilities are; and he is helping us develop these capabilities. And on the ultimate level, we and the farmer are one.

Some Personal Reflections

What a journey, what a fascinating journey it has been so far.

In 1994, after coming back from a climbing holiday in Italy, I read in a local newspaper about a crop circle that had been found near where I lived. I had a strange urge to go out and see this crop circle, even though the paper was two weeks old, it was already halfway through August and

the fields had been cut. The good news was that the stubble was still there. The location where this formation was to be found was mentioned only in approximate detail, but I was convinced that I would find it. However, Holland is flat. There are no hills. There is no way that you can look into the landscape from above. It is difficult to see things in the fields and after I had driven around for several hours I still hadn't found the crop circle. Just after I had decided to give it up I saw it lying in a field. I stopped the car, got out, walked into the field and there it was. I couldn't believe my eyes. This was the first time in my life I was looking at flattened crop. Although there was only stubble left, the formation was still easily recognisable.

One thing I noticed straight away was that the pattern I was looking at was not the same as the one that I had read about in the newspaper. The paper mentioned a big simple circle. There was even a photo included. But here in the field I was looking at a much smaller circle, with four really small circles around it. A so-called quintuplet, as I learned later.

After a while I decided to pick up my partner Janet Ossebaard, she had to see this as well. Like me, she had never seen a crop circle before.

Arriving back at my car to pick her up, I looked towards the formation for the last time and I noticed it was invisible from where I was standing. I got in the car and drove along the same stretch of road again, as I did before when I first had seen the crop circle. What really surprised me was that even from my car it was invisible. I could not see the formation. How was this possible? I had seen the crop circle the first time I went by and I had not been mistaken, the formation was there. But driving along the same length of road again I could not see it.

In hindsight this was obviously some sort of paranormal experience, but back in 1994 I was still too much of a rationalist even to take this option into consideration. For me it was just something for which there was no explanation, and although I didn't think of any paranormal possibilities, it was strange enough for me to look into the rationale of crop circles. I even decided to go to England the following year to see some "real" circles for myself.

I had just arrived in England in 1995, when I visited my first "real" crop circle, the formation near Winterbourne Bassett, the formation that formed the starting point for all my research. But was this really the starting point? Looking back I have to conclude that my paranormal experience with the crop circle in Holland was the real beginning. Isn't it strange that my jour-

ney started with some sort of paranormal event? An event that pushed me in a way to go to Wiltshire, England. In England I visited the Winterbourne Bassett crop circle, and this formation triggered my geometrical research.

For many years I have fought a battle with myself. Initially I was convinced that my decision to try to reconstruct the crop patterns had been an autonomous one. I had taken that decision and neither anybody or anything had influenced me in that decision. Perhaps it was stimulated by my visit to the Winterbourne Bassett formation in 1995, but the initiative to start making the drawings was my own. That was my strong belief. As the years went by and my discoveries kept accumulating, I was not so sure about this anymore. I became convinced that the formation had set off something in me. I seriously considered the possibility that my research was activated by that symbol, if not completely, then at least partly. No matter what, it is certain that there was some sort of influence coming from that formation. And it was not only that formation. Numerous other crop circles have had the same power of influence.

In a way, it was this influence that really encouraged me to study the geometry of the formations. I now give lectures on this subject and I have made documentaries. I have written numerous articles about this geometry and in the end I have now written this book about the crop circle shapes.
In a subtle way this book is already one level deeper. After I had studied the crop circles, I could have kept the results to myself. I was not forced to write a book about my findings; or was I? Have I just been an instrument of the phenomenon and am I still? Was it my duty to spread the word as I have done? Was that the role I had to play?
If you had told me this ten years ago, I would have laughed out loud. Now the idea that I have been influenced, the idea that I have played a role and that I am still doing so feels perfectly normal. And it has nothing to do with my ego. It is actually quite the opposite. In a way, you could say that what I have written in this book are not my own thoughts or constructs, but that it is only a reflection of what the phenomenon has awakened in me. Perhaps it even planted all the thoughts in my head in the first place. In that case nothing in this book is my original work.
There is nothing there that my ego can be proud of. You don't have to

credit me for the material presented, you should credit the phenomenon, whoever or whatever it is. I don't think it goes that far, but I am sure we are looking here at some sort of co-creation at the very least. Parts of it are my own original ideas, other parts were planted in me or at least triggered off in me.

It is a known fact that we humans can store information on subliminal levels. We see things of which we are not aware, but we will still store them somewhere in our memory. Swiss psychologist Carl Gustav Jung has studied this in depth and he took it even further. He showed that not only do we store information unconsciously, this information can cause us to act as well; and we are not aware that the subliminally absorbed information was the cause of that action. In a way we do become conscious of it again, but in a completely different and unrecognisable form and we are not aware of the original information that causes us to act. So it is not strange at all that I absorbed the crop circle shapes on a subconscious level and that those same shapes have triggered something in me that urged me to do the research that I have done. This is what advertisers take advantage of. Shapes are tremendously powerful and crop circle shapes are about the most powerful I have ever come across. Underneath this level other things have happened that were less visible and less obvious. For instance I shifted my priorities in life. Things I thought were important ten years ago are less important for me now. The most significant change took place in my appreciation of materialistic items, like cars, houses, in short: possessions. I can do with a lot less now than I could ten years ago. The crop patterns have played a major role in this change which I have seen take place in so many people who became involved in the crop circles. Other friends of mine who did not get involved with these mysterious shapes, did not change.

There is another, even deeper level at which the patterns play a role. I have become much more intuitive. I feel things and I pay attention to this feeling. In a way there are two things happening at the same time. Firstly my intuition has become much sharper, and secondly I take it more seriously. I am not paranormally gifted, I am not a remote viewer nor can I move objects at a distance, but there are things that I can do now which I could not do before I became involved in the crop circle mystery. I am convinced that these qualities were awakened by the crop circle shapes.

Perhaps if I had seen these shapes in a book instead of a field, the same thing would have happened. So the power of the shapes is not because they were laying in the crop. No, the power resides in the shapes themselves.

But if these shapes can do all this to me, then they can do the same to others. And that is exactly what is going on. The crop circle shapes do influence nearly everybody who comes in contact with them on all the same levels that they have influenced me. It is unlikely that these people will be triggered to do the same things that I have done, but something will change in them, even if it is really deep down.

A simple example is their awareness of the phenomenon itself. It is very likely that these people will become much more aware of the fact that the crop circles are a true phenomenon. This happens partly because they looked at the shapes, or perhaps even studied the shapes, the patterns of the crop circles.

The question remains: Why? Why does all this happen?

I think the phenomenon is helping humanity to make the right choices and decisions.

When I look around I see a world that is focussed very much on materialism. Everybody wants more money, more possessions, more, more, more. It has become a real battle in which the fittest will survive.

I get really sad looking at this. It is all so destructive. We are destroying everything and everybody and deep down we are so much aware of this fact. Deep down on a subconscious level we know exactly that what humanity is doing right now is completely wrong. Deep down we know it and we want the change it.

There are many ways in which you can achieve this change. Of course I could preach "Doom, doom, doom. The end of the world is nigh! Doom!!!" But I am sure this will not have much effect. Just telling people that we should change things won't help. They will listen, but then they will carry on with their lives without changing a thing. I have seen this happen many times and to be honest I think I would do the same.

What does work is pushing people in such a way that they are not aware they are being pushed, but they do change the direction in which they were heading. They are unaware, at least on a conscious level, that something is influencing them. If I had the capability to do this, I would not have to think about it, I would use it straight away.

It has taken me a long time to find out who the farmer with the sledge-hammer is but the phenomenon itself has answered this question. The 1997 Etchilhampton and 1998 Tawsmead Copse formations and many more crop circles before and after have shown beyond any reasonable doubt who he is. It is very difficult to take in but it is also unavoidable. It is hard to believe and to grasp, but I think the farmer is "us". We are the farmer. We humans are the phenomenon!

It is all done very cleverly. In a way we are communicating with ourselves. I do not know on how many levels this happens, but ultimately we help ourselves. The phenomenon, that is us, helps us to appreciate the shapes, helps us to change, helps us to develop qualities we do not have yet.

Yes, I am convinced that there is something in us, some form of energy that we do not understand yet, that is able to flatten the crop into power-ful shapes. Then we as physical beings come along and visit these so-called crop circles. We look at them and say in amazement "Oh" and "Oeh" and without realising it we absorb the message that this other part of our-selves is giving to us. We read the symbols, although we are not con-sciously aware of it, we understand the message on numerous levels and we act accordingly.

The farmer is us, we are the farmer. The farmer talks, we listen. We do, the farmer listens and starts talking again. We listen, we do. In an endless spiral loop we will progress further in our evolution. The head is helping the tail, the tail is helping the head.

Has my journey come to an end now that I know all this? No, of course not. My journey only just started, and it has certainly not ended yet. I am still travelling, and while I travel I invite more and more people to travel with me, or at least start their own journey.

During my journey so many things have already changed in my life. Some took place while I was very much aware of them and I deliberately chose to make those changes. Other changes were much more subtle and took place on a subconscious level, although I notice their effects in my life every day. If everybody were to go through these changes then the world would look very different. I even dare to say that it might look better.

In that respect it is not such a strange thought that we help ourselves by means of the shapes found in the crop. Somewhere, from a different

dimension, we push ourselves in the right direction, just as something pushed me gently into the Winterbourne Bassett formation.

Up until now it has been a most beautiful journey, a tremendously exciting journey and it still is - and I hope it will continue for a long time to come. You have already come this far, you have read this book, you have absorbed the information and you have reconstructed many of the patterns. I urge you to keep on doing this.

Take the shapes. Draw them, try to reconstruct them, interact with them. It is not about construction points and construction lines. It is about the interaction with the shapes.

Part of this interaction happens on a subconscious level, so you don't have to worry about that part. It will only happen by looking at the shapes. Another part will be easier to notice. You will become fascinated by the subject, you will start reading articles and books about it. Perhaps you will go out to a field to see an actual formation. But most importantly you will probably change things in your life. You are going to do things you haven't done before, you will obtain new qualities and perhaps you will even change the general direction of your life.

Is there one ultimate symbol? I have considered that for a long time. I thought that there had to be one unifying shape. The shape of shapes. Just as Albert Einstein was convinced that there has to be one unifying law of physics, a law that describes everything. After many years of research I have come to the conclusion that there is no such thing as a shape of shapes.

However, I do think that one symbol can be more powerful than another. One symbol can trigger more thought, more changes than another, but there is no unifying symbol. There is no one single symbol of which you can say: Look, that is the symbol of symbols. I am even convinced that many symbols are very personal. A shape that triggers a lot in me, perhaps won't even touch you, neither on a conscious level, nor on a subliminal level. Shapes that do a lot for you, perhaps don't influence me.

Now you have come this far in this book, your journey has started. Do not stop. In order to motivate you even more, I have included some crop circles, which have for different reasons made a deep impression on me. It may have been their shape, or several anomalies that surrounded the formation. It may have been because I have had some very intensive

personal and paranormal experiences in them. They are all crop circles that have touched me deeply and which have guided me in my journey.

I wish you lots of wisdom for your journey.

9. Some special formations

Introduction

Of course most crop formations are special. I have been quite overwhelmed by many of them. But of the crop circles that have made a deep impression on me, that have influenced me, there are some formations that are more special than other ones. And there are formations that are really special. The ones I want to show you on the following pages were very special for different reasons. At least they were very special to me.

Hackpen Hill, UK, 1999

When I saw the Hackpen Hill formation of 1999 on the Internet I was

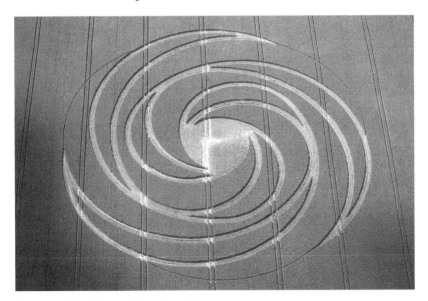

Hackpen Hill, Wiltshire, UK. 4 July 1999.

stunned. This was one of those crop circles that made me fall silent. That summer of 1999 I drove over to England and before checking into a hotel or finding a spot on a campsite I went to Hackpen Hill. I drove from Holland to England and straight to this hill in one go.

Driving up the hill I realised that I would have the best view from halfway up. So I stopped the car, got out and looked down. I was even more impressed.

From the very moment of its appearance I was struck by its pattern: a pattern that seemed to consist mainly of overlapping and/or touching spirals -and a pattern that - according to many - would take a lot of thought before it could actually be deciphered.

This turned out to be true. It took me quite a while before I had figured out how this formation worked. I tried every possible spiral, but with no satisfactory result. Then, all of a sudden, it dawned to me. It is not made of spirals, it is made of circles!

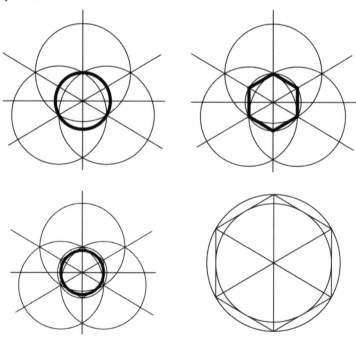

The base is formed by a hexagon with a circle around it and a circle within it. This basic hexagon can be constructed by means of the 'basic pattern' as shown above. Now construct the next four circles.

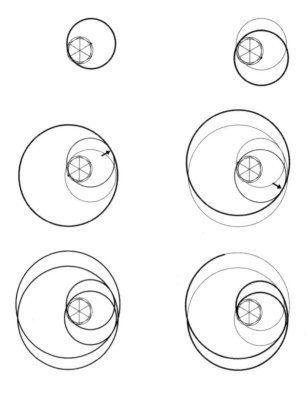

The constructions shown in the diagrams can be repeated three times.

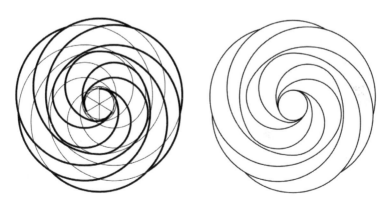

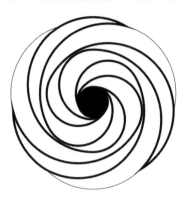

Barbury Castle, UK, 1999

The formation that appeared at the foot of Barbury Castle on 23rd July 1999 is for different reasons one of my all time favourites. When I first saw it I knew right from that moment it would contain some very intriguing but hidden geometry and I decide to analyse this crop circle once I was back in Holland.

Less than a week later, while I was still in England, Donald Fletcher from London walked up Barbury Castle. While he looked at the circle he witnessed and filmed a bright ball of light floating over the field towards the formation, following the perimeter of the formation before floating further, accelerating and flying out of sight. The ball of light clearly interacted with the shape of the crop circle.

I was already planning to study its geometry, but after hearing about this encounter and after having seen the footage shot by Donald numerous times, and which I later incorporated in my documentary 'Contact', I was determined to analyse this formation thoroughly. Because it is such a special formation, I will show all the steps to reconstruct this beauty.

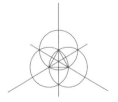
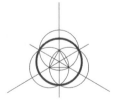

At this point I want you to notice that the smaller triangle and the big triangle are integrally connected to each other. The size of the one is fixed by the size of the other. If one changes size, the other one will change size with it. It is imported to understand that they form a unity. It is this unity that gives the crescents their size. It is because of this unity that the crescents could not have been of a different size, nor could they have been placed at a different spot.

The diagram on the right shows once more the very intriguing hidden triangular geometry of this formation. In the year 2000 I had to go back to the field where this formation had come down the year before. Standing on top of Barbury Castle I was amazed to see the shape of the formation in the crop again. Where the formation had been the year before the new crop was much darker. It turned out that on those spots where the crop was laid down in 1999, the new crop in 2000 looked much younger and was about 15% taller than that in the rest of the field. Because of this fact I promoted this formation from being very special to the league of all time favourites. The geometry, the balls of light, the ghost image. It truly deserves it.

Bainbridge, Ohio, USA, 2003

In August 2003 a crop circle was discovered near Bainbridge, Ohio, USA, which is near Serpent Mound. This crop circle is special for various reasons. It appeared in soybeans, which is very rare. There were no tractor lines or tramlines in the field. Soybeans grow like spaghetti and you can not walk through it without leaving a trace, but no tracks of human activity were found. Nobody had walked the field before the discovery of the

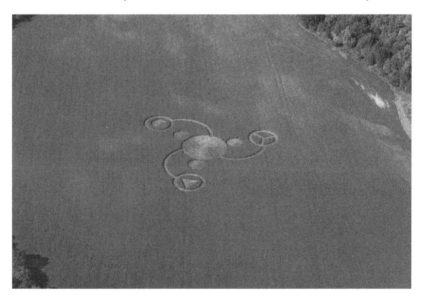

Bainbridge, Ohio, USA. Late August 2003

112

formation. The pattern was measured precisely and investigated by Jeffrey Wilson. The downed plants showed traces of what looked like burning, which was not found on the standing plants. All in all this was one of the very best examples of a "real" crop circle that I have ever come across. This particular one lined up precisely with the snake-like monument on Serpent Mound, hence the name.

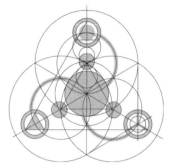

Although it is a very powerful shape, it does not at first sight indicate that there is a lot of hidden geometry. I invite you to study thoroughly the diagram on the right and be amazed by all the "coincidences" you will find. You will discover why I think this crop circle is so special. Every element is linked to all the other elements. Not one single piece is unconnected.

Adam's Grave, UK, 2003

The Adam's Grave formation, the so-called "Swallows", had a very elegant and elaborate geometry that certainly made it special, but for me personally it was extraordinary. It had a big influence on me on different levels and a great impact on my life. That is why I want to share this formation with you.

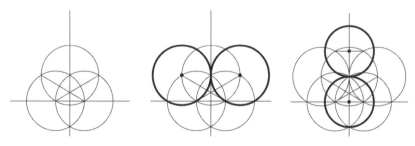

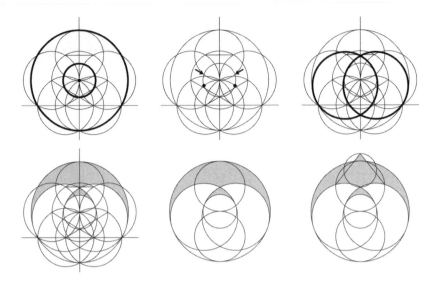

The diagram in the middle of the bottom row shows clearly how all the different elements are contained within a circle. This can be repeated in the lower circle and repeated again in the circle further down, thus creating a fractal.

Adam's Grave, Wiltshire UK. 4 August 2003.

Appendix

I will illustrate some examples of crop circles based on different types of geometry. If necessary, I will show how a particular geometry is constructed, though there is a limitation as to what will be shown. Beside one-fold geometry, which is basically a circle, the only constructable geometries are: two-fold, three-fold, five-fold, seventeen-fold, two hundred and fifteen-fold and all their multiples, such four-fold, eight-fold, sixteen-fold, but also six-fold, twelve-fold, etc. All examples can be constructed with the aid of the basic-pattern.

Two-fold geometry

This is a beautiful example of two-fold geometry. The formation came down on July 28, 2001, near the village of Stanton St Bernard in Wiltshire, England.

Three-fold geometry

Look at the Introduction to see how three-fold geometry is constructed. Its constructed 'basic pattern' will also be used for the construction of five-fold geometry and the construction of seven-fold geometry. The diagram shows the three-fold geometry of the Meonstoke formation of July 23, 1999.

Four-fold geometry

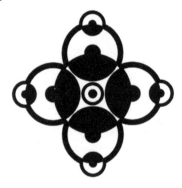

Four-fold geometry is basically two-fold geometry doubled, although this is not completely accurate. Look at this diagram of the formation that came down on August 1, 1999, near Cheesefoot Head in Hampshire, England and compare that with the two-fold geometry formation of Stanton St Bernard (see above).

Five-fold geometry

Throughout the ages five-fold geometry has intrigued humanity. This striking example of five-fold geometry was formed on July 13, 2003 near Avebury Trusloe, Wiltshire, England. At the end of this chapter I will explain how five-fold geometry can be constructed.

Six-fold geometry

Six-fold geometry can easily constructed by doubling three-fold geometry. The Barbury Castle, Wiltshire, England formation of April 20, 1997 in oilseed rape, is a nice example of a crop circle based on six-fold geometry.

Seven-fold geometry

Although it is impossible to construct 100% accurate seven-fold geometry, there are methods that come very close to perfection, so much so that you won't notice with the naked eye that it is not perfect. The diagram shows the crop circle that came down on the August 5, 2000 near the village of Wilsford, Wiltshire, England.

Eight-fold geometry

Like four-fold is not really the double of two-fold geometry, so is eight-fold geometry not the double of four-fold geometry. The diagram on the left is of the crop circle that appeared near Silbury Hill, Wiltshire, England on June 11, 2000. The rings that look randomly placed are actually very precisely placed, using eightfold geometry.

Because this is such a fine example of eight-fold geometry, I will show some more examples of this formation.

The left diagram shows how the rings follows the rules of eight-fold geometry. The right diagram shows the intriguing geometry of the core. At first glimpse, the core seems to consist of two squares, but at closer inspection that is not the case. It is actually based on a 16-pointed star. Every second point of the star is used.

The diagram on the left shows the actual core. The diagram on the right shows how the core would have looked if it would have been two squares.

Nine-fold geometry

One of the most intriguing crop circles based one nine-fold geometry appeared near Cherhill on July 17, 1999. Since I have discussed this formation earlier in this book, I will show here the crop circle that was found on August 8, 2000 near Stanton St Bernard in Wiltshire, England. Although it is less elaborate than the Cherhill pattern, it is still a beautiful example of a nine pointed star crop circle.

Constructing five-fold geometry

Constructing five-fold geometry is not difficult. The method shown is 100% perfect. This method was already known by the Greek mathematician Euclid, who lived some 2500 years ago.

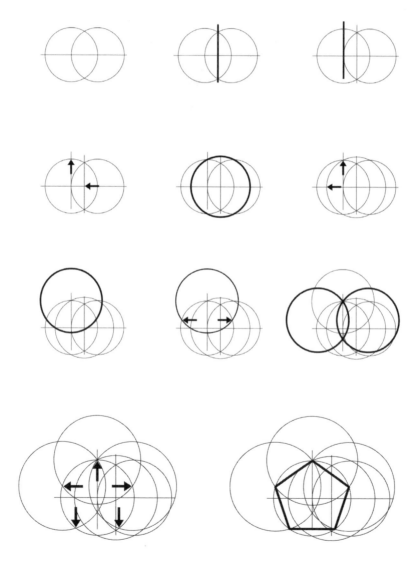

Constructing seven-fold geometry

Let me first explain that it is impossible to construct a precise heptagram using a ruler and compasses, though there are different methods that come close. The method shown here is relatively simple and is almost 100% accurate.

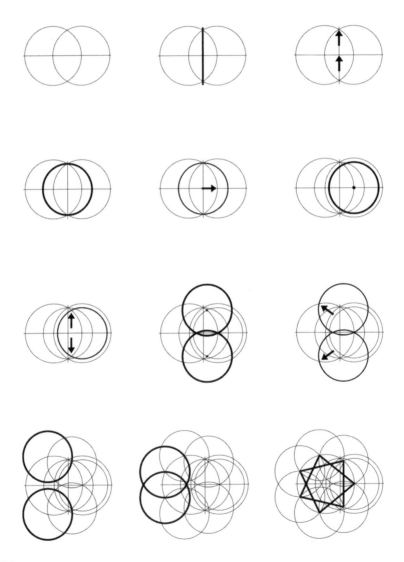

Constructing nine-fold geometry

It is impossible to construct precise nine-fold geometry using a ruler and compasses, though there are different methods that come close. The method shown here is perhaps the most simple, is almost 100% accurate and has oddly enough a six pointed star as starting point.

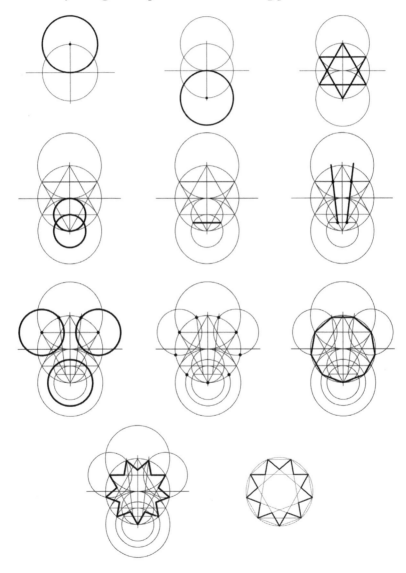

Acknowledgements

So far, my journey has been a very exciting one, and full of adventure. During my tour of discoveries, many people have crossed my path. Some of these had great influence on the direction of my journey, others less so, but they all left their mark, and I met each for a specific purpose. Although many may not even be aware of the influence they have had, I still wish to thank them for what they have done to make my research possible. I will try to thank each and everyone of you personally. Forgive me if I forget anybody.

A very special and important role has been played by Janet Ossebaard. She has been my travel companion from the start till almost the very end. She was there in Winterbourne Bassett in 1995 and in the Julia Set at Stonehenge a year later. She was with me in the Koch fractal at Silbury Hill and she was there when I studied the ever so important underlying lines in the Tawsmead Copse crop circle. Thank you, Janet. You have been a continuous source of motivation and inspiration.

Some people probably didn't know they played a tremendously important part. John Martineau is one of them. His 'A Book Of Coincidence' was a real eye-opener for me. While reading it, I came across the work of Wolfgang Schindler and I met him in person. I thank you both for sharing your thoughts and discoveries with me.

Over the years many people have influenced my journey through the magical world of geometry in a very positive way. One of those people is Michael Glickman. He was also the one who pointed out the book of John Martineau to me. And I thank Andreas Müller, Martin Keitel, Freddy Silva, Allan Brown, Jan Loenders and Nick Kollerstrom for all the countless thought exchanges about shapes and geometry.

Others who have been of equal importance are Mark Fussell, Stuart Dike,

Frank Laumen, Charles Mallett, Paul Vigay, Eltjo Haselhoff, Roeland Beljon, Nancy Polet, Colin Andrews, Peter Sörensen, Busty Taylor, Ron Russell, Werner Anderhub, Ilyes, Robert Boerman, Andy Thomas, Nancy Talbott, Nick Nicholson, Sven Reuss, Gordon Stewart, Jonah Ohayv, Bob en Gill Nicholas and of course their children and their dog Reiki. Barbara Lamb, Shawn Randall, Eva Brekkestø, Jan Dupont, Jennifer Stein, Carl Nevin, Shireen Strooker, Mark Haywood, Dirk Möller, Lucy Pringle, Brad Pitt, Patricia Murray, Maki Masao, Bram Vermeulen, Graham Slater, Chad en Gwen Deetken, Donald Fletcher, Klaas and Dini van Egmond, Michael Yudowitz, Fabio Borziani, Robbert van den Broeke, Dirk Laskowsky, Ulrich Kox and many others. I thank you all.

A special thanks is required to Linda Moulton Howe, who has witnessed part of my journey from up close. She – in her own unique and personal way – motivated me to bring this book to a successful conclusion. Thank you Linda.

Many of you have become friends for life. For that alone I am most grateful.

Last but not least, I would like to thank those who were the reason for my journey in the first place: the Circle Makers.

Bert Janssen

Photo credits

p. 112 Bainbridge, Ohio, USA. Late August 2003.
© Jeffrey Wilson. http://www.cropcirclenews.com

Colour photograph section

Avebury, Wiltshire, UK. 28 July 2002.
© Janet Ossebaard. http://www.circularsite.com

Barbury Castle, Wiltshire, UK. 23 July 1999.
© Janet Ossebaard. http://www.circularsite.com

Beckhampton, Wiltshire, UK. 28 July 1999.
© Janet Ossebaard. http://www.circularsite.com

Cherhill, Wiltshire, UK. 17 July 1999.
© Janet Ossebaard. http://www.circularsite.com

Hackpen Hill, Wiltshire, UK. 4 July 1999.
© Janet Ossebaard. http://www.circularsite.com

Liddington Castle, Wiltshire, UK. 21 July 1999.
© Janet Ossebaard. http://www.circularsite.com

Milk Hill, Wiltshire, UK. 1 Juli 2000.
© Janet Ossebaard. http://www.circularsite.com

Milk Hill, Wiltshire, UK. 13 August 2001.
© Janet Ossebaard. http://www.circularsite.com

Roundway, Wiltshire, UK. 31 July 1999.
© Janet Ossebaard. http://www.circularsite.com

Contact information & background of copyright owners:

Lucy Pringle - Author, Aerial Photographer, Crop Circle Researcher and Lecturer
http://home.clara.net/lucypringle

Janet Ossebaard - Author, Photographer, Crop Circle Researcher and Lecturer
http://www.circularsite.com

Frank Laumen - Photographer (Crop Circles and Ancient Sites)
http://www.franklaumen.de

Robert Boerman - Crop Circle Researcher, Chairman Ptah Foundation
http://www.dcca.nl

Jeffrey Wilson - Crop Circle Researcher
http://www.cropcirclenews.com

Ron Russell - Crop Circle Research, Tours, Lectures
http://www.cropcircles.org

Roeland Beljon - Crop Circle Researcher, Photographer

DARWIN'S MISTAKE
Dr Hans Zillmer

Yes, there were cataclysms (among them The Flood) in the course of history, but no, there was no evolution. Published in nine languages, this international bestseller puts the latest discoveries and new evidence against Darwin's Theory of Evolution. The author proves what seems unthinkable to us today: Darwin was wrong.

*292 Pages. Paperback. Euro 22,90 * GBP 14.99 * USD $ 19.95. Code: DMIS*

SAUNIERE'S MODEL AND THE SECRET OF RENNES-LE-CHATEAU
André Douzet

After years of research, André Douzet discovered a model ordered by abbé Bérenger Saunière. Douzet reveals that Saunière spent large amounts of time and money in the city of Lyons... trips he went on in the utmost secrecy. Douzet finally unveils the location indicated on the model, the location of Saunière's secret.

*116 Pages. Paperback. Euro 14,90 * GBP 7.99 * USD $ 12.00. Code: SMOD*

THE TEMPLARS' LEGACY IN MONTREAL, THE NEW JERUSALEM
Francine Bernier

Montréal, Canada. Designed in the 17th Century as the New Jerusalem of the Christian world, the island of Montreal became the new headquarters of a group of mystics that wanted to live as the flawless Primitive Church of Jesus. But why could they not do that in the Old World?

*360 pages. Paperback. GBP 14.99 * USD $21.95 * Euro 25.00. Code: TLIM*

Available from the publishers

NOSTRADAMUS AND THE LOST TEMPLAR LEGACY

Rudy Cambier

Nostradamus' Prophecies were *not* written in ca. 1550 by the French "visionary" Michel de Nostradame. Instead, they were composed between 1323 and 1328 by a Cistercian monk, Yves de Lessines, prior of the Cistercian abbey of Cambron, on the border between France and Belgium. They reveal the location of a Templar treasure.

The language spoken in the verses belongs to the medieval times of the 14th Century, and the Belgian borders, not the French Provence in the 16th Century. The location identified in the documents has since been shown to indeed contain what Yves de Lessines said they would contain: barrels with gold, silver and documents.

*192 pages. Paperback. USD $ 17,95 * GBP 11,99 * Euro 22.90.*
Code: NLTL

THE STONE PUZZLE OF ROSSLYN CHAPEL

Philip Coppens

This book will guide you through the theories, showing and describing where and what is being discussed; what is impossible, what is likely... and what is fact.

The history of the chapel, its relationship to freemasonry and the family behind the scenes, the Sinclairs, is brought to life, incorporating new, forgotten and often unknown evidence.

Finally, the story is placed in the equally enigmatic landscape surrounding the chapel, from Templar commanderies to prehistoric markings, from an ancient kingly site to the South, to Arthur's Seat directly north from the Chapel – before its true significance and meaning is finally unveiled: that the Chapel was a medieval stone book of esoteric knowledge.

*136 Pages. Paperback. Euro 14,90 * GBP 7.99 * USD $ 12.00.*
Code: ROSC

Available from the publishers

THE CANOPUS REVELATION
Stargate of the Gods and the Ark of Osiris

Philip Coppens

The identification of the constellation Orion with the Egyptian god Osiris has become engrained in human consciousness, yet it is one of the biggest misunderstandings. Canopus, for Egypt the South polar star, is the second brightest star in the sky and interplays with Sirius in such a way that ancient accounts say they control time. Furthermore, Canopus was believed to allow access to the Afterlife - the domain of Osiris. Canopus was specifically identified with his Chest, his Ark, in which he was transformed from mere mortal to resurrected supergod. This book radically reinterprets the most powerful myth of Osiris and Isis in its proper context, offering full understanding both from historical and cultural perspectives, and shows the way forward... what did the ancient Egyptians believe that would happen to the soul?

*216 pages. Paperback. USD $ 17,95 * GBP 11,99 * Euro 20.90.*
Code: CANO

CROP CIRCLES, GODS AND THEIR SECRETS
Robert J. Boerman

For more than 20 years, all over the world, mankind has been treated to thousands of crop circle formations, and until now, nobody has been able to explain this phenomenon. In this book, besides a scientific and historical section, you can read how the author links two separate crop circles. They contain an old Hebrew inscription and the so-called Double Helix, revealing the name of the 'maker', his message, important facts and the summary of human history. Once he had achieved this, he was able to begin cracking the crop circle code.

*159 Pages. Paperback. Euro 15,90 * GBP 8.99 * USD $ 14.00.*
Code: CCGS